IMAGES
of America

BATH COUNTY
VIRGINIA

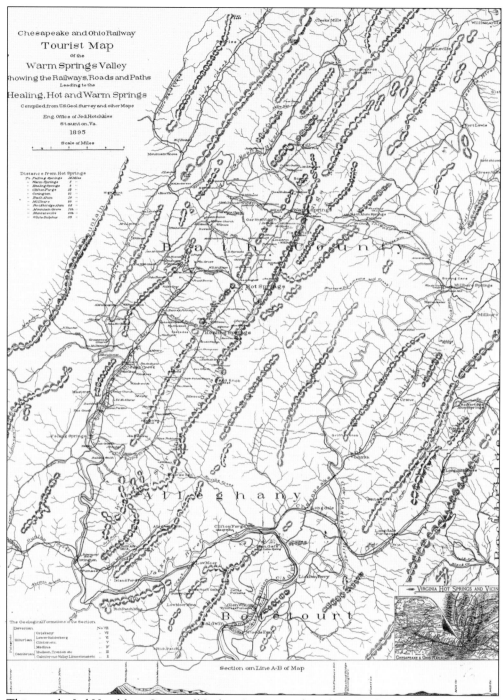

This map by Jed Hotchkiss, Stonewall Jackson's cartographer, shows Bath County in 1895. Most of the farms and homes west of Warm Springs Mountain are identified by owner.

IMAGES
of America

BATH COUNTY
VIRGINIA

Margo Oxendine

ARCADIA
PUBLISHING

Published by Arcadia Publishing
Charleston SC, Chicago IL, Portsmouth NH, San Francisco CA

Printed in the United States of America

Library of Congress Catalog Card Number: 2003109965

For all general information contact Arcadia Publishing at:
Telephone 843-853-2070
Fax 843-853-0044
E-mail sales@arcadiapublishing.com
For customer service and orders:
Toll-Free 1-888-313-2665

Visit us on the Internet at www.arcadiapublishing.com

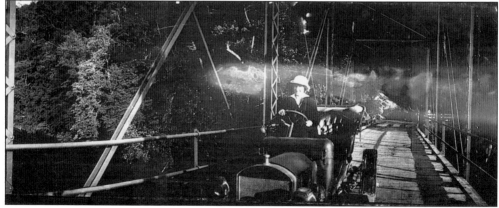

Mrs. J.T. McAllister crosses the Jackson River at the wheel of one of the region's first automobiles.

CONTENTS

ACKNOWLEDGMENTS

This book is dedicated to Edna Helmintoller, the late Elaine Madlener, and the late Eliza Wise. These ladies, whom I call the "triumvirate of local history," dreamed of a Bath County Historical Society, and then, in 1969, made it happen. Their generosity, dedication and attention to detail are still appreciated today.

I, too, had a dream: to publish some of the hundreds of historical photographs in the society's archives. But it was Selby Schwend, our president, who pushed me with gentle grace over the threshold from procrastination to reality. I am grateful for his assistance, talent, dogged determination, and good humor.

I thank the writers who came before me: Hugh Gwin, for *Historically Speaking: True Tales of Bath County*; the late Fay Ingalls, for *The Valley Road*; and those who collaborated to publish *The Bicentennial History of Bath County, Virginia*. My copies of these books are dog-eared; I am in your debt for facts, dates, and figures.

Special thanks to Jean Bruns, Betsy Byrd, Linda Weiss, Laten Bechtel, Jim Tennant, and everyone else who shared their great old family photos.

I am also indebted to long-gone, prolific photographers such as J.T. McAllister and Henry Wise Hoover; did they ever imagine their legacy would endure for a century or more? And, were it not for the late George Washington Cleek's obsession to collect, publish, and preserve Bath history, many of these photographs would be forever lost in a maze of mystery. Heartfelt thanks to all who, like George, jotted down who, what, when, and/or where on the backs of their treasured photos.

INTRODUCTION

Bath County's resplendent history dates back much further than its founding in 1791. Indeed, some folks living here today can cite ancestors who were making history in 1747, when Bath was still part of Augusta County. In 1756, for instance, Shawnees attacked settlements along the Jackson River; among those killed were John Byrd and George Kincaid—surnames still found in our little phone book.

Long before the county charter was signed, Bath's mineral springs were attracting the sick and the weary traveler. By 1766, enterprising settlers decided that erecting some sort of accommodation for those travelers might prove a lucrative venture.

Thus it was that, on a pristine, pastoral site where hot springs bubbled from God's green earth, Thomas Bullitt built a hostelry he called "The Homestead." It did not take long before a wayside inn for the infirm earned renown as a social and recreational mecca. Today, The Homestead is one of the nation's finest spa, golf, and conference resorts.

Yet, even before The Homestead came to the fore as a tourist destination, there was the Warm Springs Hotel. The stately white Colonial hotel and cottages were attracting visitors before 1800. In 1761, the hotel erected a clapboard bathhouse around its sparkling 98-degree mineral springs. By the time the ladies' bathhouse was constructed in 1836, the glorious, bustling Warm Springs Hotel was the most popular stop along the famed Virginia Springs circuit. Remember: at that time, even the noted White Sulphur Springs were part of Virginia.

Before the automobile, most travelers to "The Warm" and "The Hot," as they were known, arrived by train at the Millboro depot. Thus, Millboro Springs itself was a popular tourist enclave; the gentry would rest up there before the arduous 25-mile stagecoach trek to The Warm. Along the way, many would calm their nerves and take refreshment at Bath Alum Springs, the midway point. The old inn and tavern grounds are today a splendid private estate.

It is indeed amazing to see how many great estates of old still grace the landscape of Bath County.

There's the meticulously restored Warwick mansion in Hidden Valley, where Judge James Woods Warwick and his family once held forth. The house, a splendid example of Greek Revival architecture, fell into disrepair after the judge's widow died in 1898. For many decades, it served as a humble hunt camp. It languished, forlorn and desolate, until 1990, when the U.S. Forest Service granted a 30-year lease to Ron and Pam Stidham. They polished and preserved the mansion so well, with such attention to historic detail, that Hollywood came calling. The movie *Sommersby* was filmed there in 1992.

Other historic places with fascinating histories stand proudly today: Boxwood, Gramercy, Anderson Cottage, Oakley, Fort Lewis, Sitlington, Woodland Cottage, Malvern Hall, even the Mustoe House, built in 1780 and Bath's oldest standing structure. They are a testament to generations with a reverence for history, a sense of continuity, and a flair for preservation.

Many of Bath's smaller towns and villages look much the same now as they did in these early photographs. Millboro, Mountain Grove, Williamsville, Healing Springs—the buildings you find there today may serve a different purpose, but their appearance has changed little through the decades.

The village of Bacova, built as a "company town" when Tide Water Hardwood was the largest lumberyard on the East Coast, survived and thrived long after the demise of the mill.

The same can be said for Bath's people. The Roberts and the Burns clans still make their homes in Burnsville. The Hirshes are still at Meadow Lane. The Cleeks still live near Bolar, on the farm they've owned for almost 200 years. The same is true of the Brattons, just down the road from the Cleeks. In Warm Springs—called Germantown before that nasty first World War—Jean Bruns continues a tradition her ancestors began in 1876: hospitality at Anderson Cottage.

In the chapter on Healing Springs, you'll find a group of men who worked for Jakey Rubino at his mineral water bottling plant in 1895. They are Chaplins, Laymans, Sneads—and their descendants by that name drive past Rubino Hill nearly every day of the week. The Williams & Herman Store photo? Today, Herman descendants live within a stone's throw in either direction of the old store.

One of the most priceless things about history is that it shows us faces and places that are long gone. In these pages, you'll find photographs of many of Bath's early "movers and shakers"— Col. William Terrill, a crusty old coot with a blessed life turned tragic; attorney John Wilson Stephenson and his family, going about daily life in 1892; African Americans who served the gentry and made history in their own right; and the Cleek sisters who married the Revercomb brothers. You'll see today's busy highways as they were in the days of horses, carriages, and early horse-less carriages. We've included a dramatic photograph of The Homestead smoldering in ashes, the day after the 1901 fire. Some of Bath's favorite teachers reappear in these pages, smiling in the bloom of youth. And quite a few of today's responsible older adults can be spotted clowning around in grade school.

These images were selected with both residents and visitors in mind. Whether your acquaintance is auld or new, it is hoped these depictions of life as it once was provide a glimpse of the fascinating history that made Bath County, Virginia, what it is today.

One

WARM SPRINGS

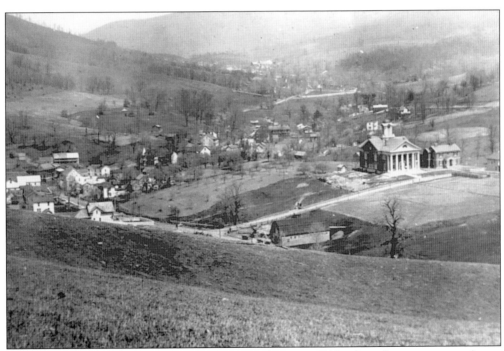

An overview of Warm Springs, taken sometime between 1913, when the current courthouse was built, and 1925, when the old Warm Springs Hotel, in the far distance, was demolished.

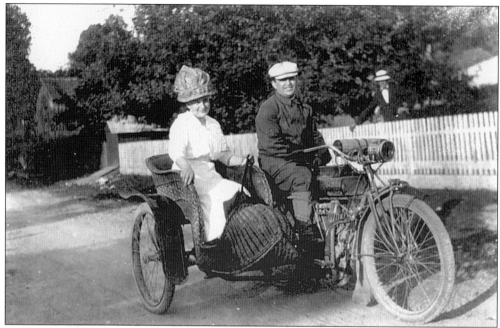

William and Georgia Snider, nattily-attired Warm Springs gadabouts, toodled around town on their Indian motorcycle, with wicker sidecar.

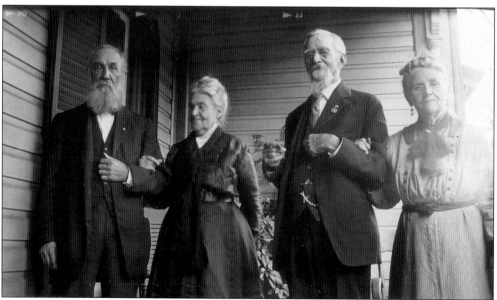

J.E. and Emma Payne, left, and William and Maggie Ervin McAllister, right, celebrated their joint 50th wedding anniversary on October 27, 1919. The couples lived in Warm Springs, within a stone's throw of each other, for more than 50 years.

Dr. William Sheppard was a Presbyterian minister and, in 1890, the first African-American missionary to the Belgian Congo. During this 1900 visit to Warm Springs, Sheppard posed with his mother, Fanny. While here, he spoke at the Presbyterian Church about horrific conditions faced by the Congolese working on King Leopold's rubber plantations. By chance, the Belgian ambassador was also in Warm Springs; reporters following him heard Sheppard speak. The atrocities of the Congo made newspaper headlines across the country and sparked an international investigation. As a result, control of the Congo was wrested from Leopold; conditions improved almost immediately.

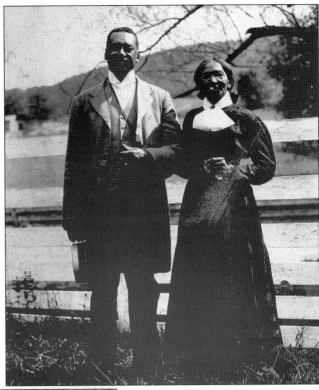

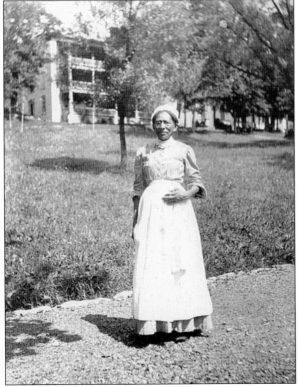

"Aunt Fanny" Sheppard, born into slavery, was the longtime attendant at the Ladies' Pool in Warm Springs. A resident remembers, "Aunt Fanny taught my mother and other girls to swim by tying a sheet around the middle and launching the pupil into the pool."

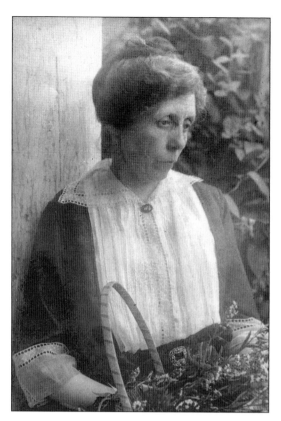

Miss Somers Anderson came to Warm Springs by stagecoach at the age of 10 and moved into the home of her stepmother, Margaret Foxhall Daingerfield Anderson. For more than 125 years, an Anderson descendant has lived at "Locustlyn," later "Anderson Cottage." For a time known as "Miss Daingerfield's School for Girls," Anderson Cottage evolved from schoolhouse to gracious summer inn solely through the influence of Miss Anderson. Her love of flowers and gardening is evident to this day. She ran the inn until shortly before her death in 1952 at the age of 85. Her great-niece, Jean Randolph Bruns, holds forth as hostess at Anderson Cottage today.

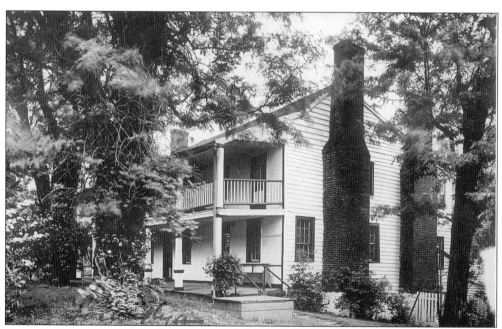

"Locustlyn" was renamed Anderson Cottage after the locust trees died.

The Randolph family poses in 1931 at Anderson Cottage, the milieu of Mrs. Randolph's aunt, Somers Anderson. From left to right are Jean Graham, Beverley, Jean Graham McAllister Randolph, "Snowball," and O. Robbins Randolph. Throughout this photo album, "Snowball" appears at nearly every gathering. (Photo courtesy Jean Bruns.)

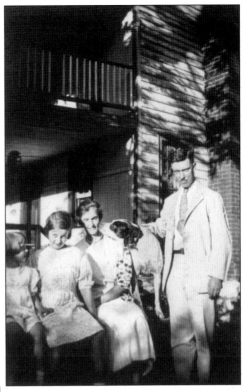

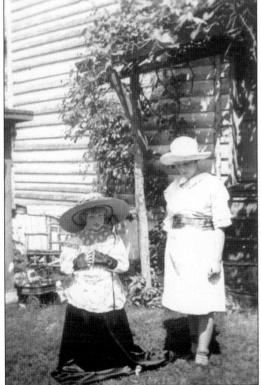

Little Jean Graham Randolph (Bruns) and her sister Beverley Randolph (Knight) loved digging into the trunks in the attic of Anderson Cottage and playing dress up; this photo was taken in 1934. (Photo courtesy Jean Bruns.)

13

Dr. Frank Hopkins was the son of Dr. Benjamin F. Hopkins and father of Elinor.

Artist Elinor F. Hopkins gained acclaim in Virginia and New York.

Miss Irene Hopkins was a daughter of Dr. Benjamin Hopkins. On the reverse of this photo, someone has written "Irene Hopkins, Germantown Belle." Dr. Benjamin Hopkins moved his family from "The Healing" to "The Warm" in 1865. At that time, the village was known as Germantown.

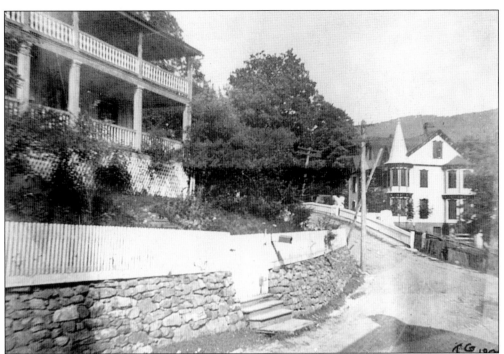

Hickman's Corner is seen as it appeared in 1904, looking northeast. Dr. Benjamin Hopkins' house, in the foreground, has since been demolished; so has the elaborate gabled Victorian on the right, which was owned by William and Maggie McAllister. When the Victorian was torn down, discovered at its core was the log cabin that is today known as Francisco Cottage.

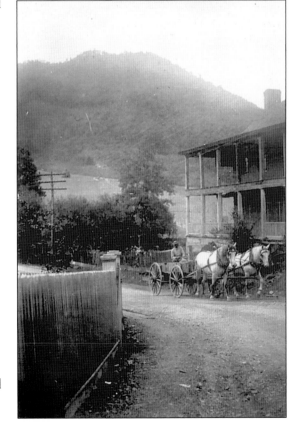

Hickman's Corner is pictured in 1900, looking southwest. On this corner today stands the former county administration building, later converted to apartments and now part of the Inn at Gristmill Square.

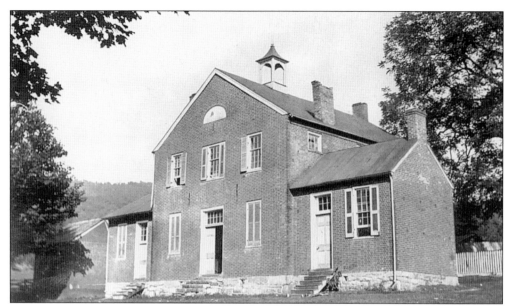

The Bath County Courthouse, adjacent to the jail, was at this site until 1908. Note the cupola on the roof; today, it can be seen atop the old Christ Episcopal Church.

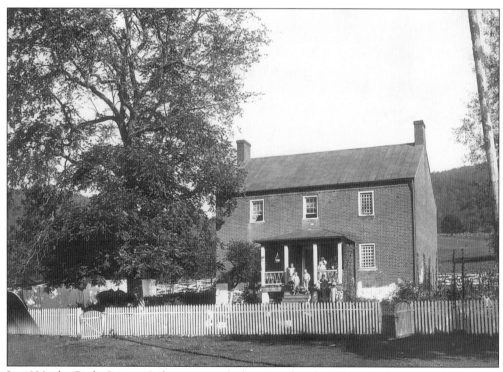

In 1899, the Bath County Jail was part of what is today the Warm Springs Inn. As was the custom, Sheriff John E. Gum lived there with his family, pictured on the porch.

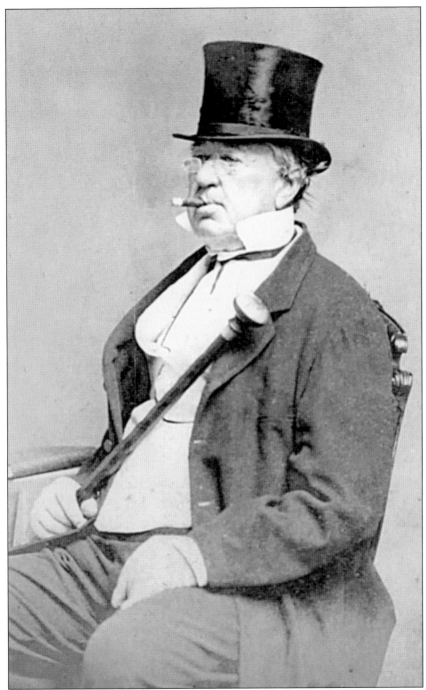

Col. William Henry Terrill served for decades as Commonwealth's Attorney for Bath County, and later represented the region as a state legislator. The Terrill family home, "Rose Hill," was near Christ Church. Four of the Terrill sons fought in the Civil War. William, a West Point graduate, was a Union General; James, a VMI graduate, was a Confederate General. Both William and James were killed during battles, as was their younger brother, Phillip. Only George Parker Terrill, a physician, survived the war.

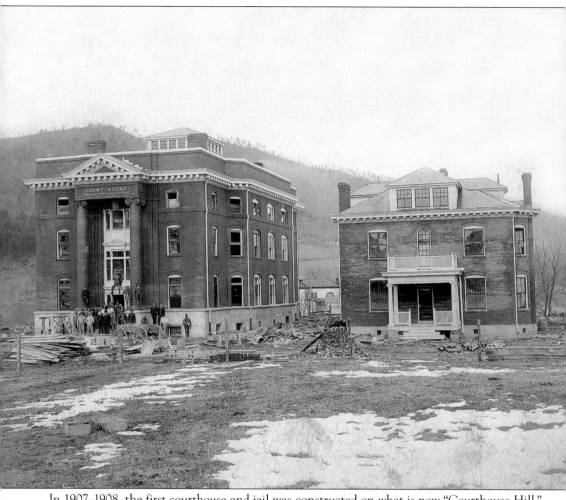

In 1907–1908, the first courthouse and jail was constructed on what is now "Courthouse Hill." It was designed by noted architect Frank P. Milburn. It was built and furnished for less than $43,000. The county clerk pushed for approval to install a new-fangled fireproof vault in his office. This proved providential when the courthouse was destroyed by fire on November 22, 1912. The only record book lost was one the clerk left sitting on his desk overnight.

Pictured in front of the
courthouse on April 29, 1936, are
county treasurer Robert Mustoe,
left, and H.C. Givens.

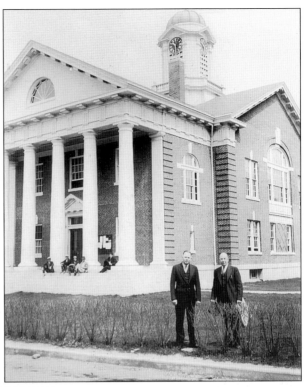

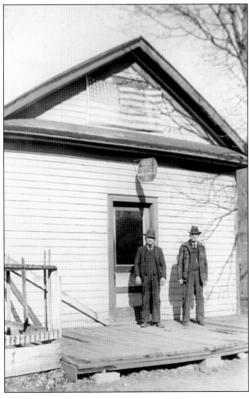

Pictured in front of the Warm Springs Post
Office in 1938 are Postmaster Robert C.
Wilkinson and his assistant, Harris Hicks.

19

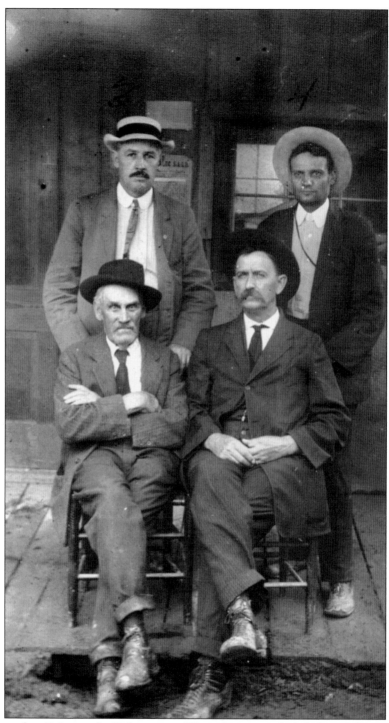

"The Powers that Be" in early 20th-century Warm Springs included, from left to right, these four dour-faced, influential gentlemen: (seated) John Criser and Clerk of Courts Floyd L. LaRue; (standing) county treasurer and Warm Springs Bank president George Brown Venable and Jonas Showalter, editor of the *Bath County Enterprise*.

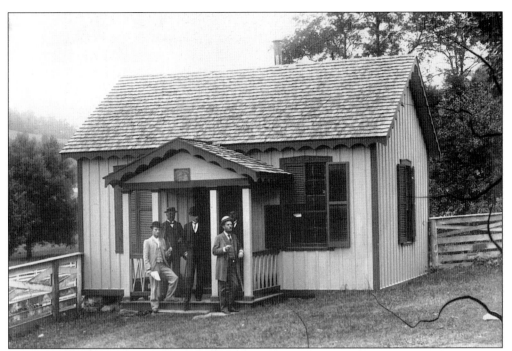

The law office of attorney William Miller McAllister, on the grounds of what was then the Bath County Courthouse. Pictured from left to right are attorneys Joseph T. McAllister, Hale Houston Byrd, William McAllister, and, on far right, Reverend Brown.

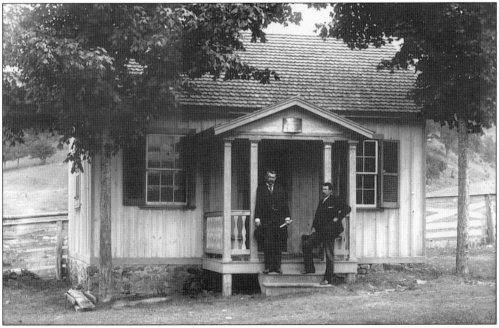

The law office of attorney John W. Stephenson Sr. sits adjacent to William M. McAllister's law office. Stephenson, left, often tried cases with fellow attorney George A. Revercomb, right. In the early 1900s, a team of 20 mules moved this building to the site of the present courthouse; today, Stephenson's office is the Bath County Historical Society museum.

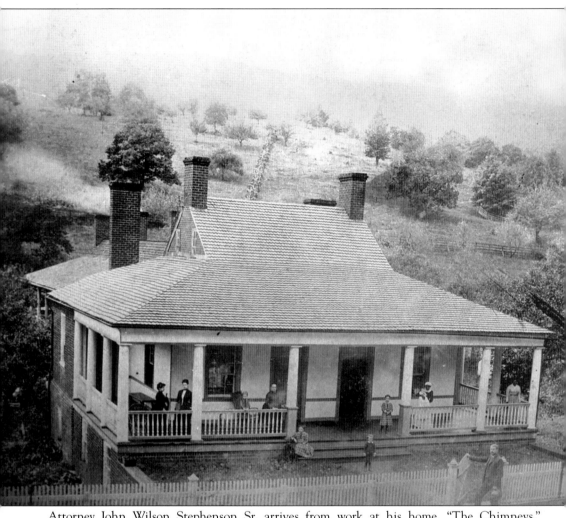

Attorney John Wilson Stephenson Sr. arrives from work at his home, "The Chimneys," in Warm Springs. On the porch, from left to right, are unidentified, Eliza Jane Warwick Stephenson, Margaret Stephenson, Grandma Eliza Warwick, Gatewood Stephenson sitting on steps, John Jr. standing on sidewalk, Charlotte Stephenson, baby Constance Stephenson, and two unidentified servants.

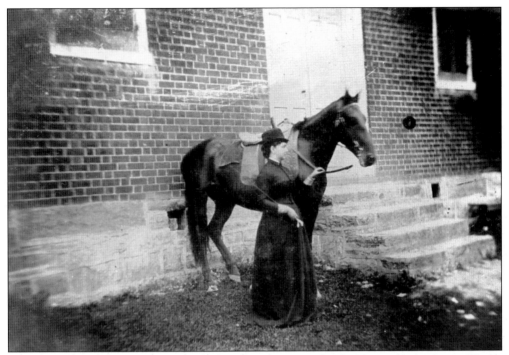

Eliza Jane Gatewood Warwick, with her horse "Bess," was the daughter of Judge James Woods Warwick, who built the Greek Revival mansion on the Warwickton plantation in Hidden Valley. She married attorney John Wilson Stephenson.

Joseph T. McAllister—author, amateur historian, photographer, attorney—was quite the bon vivant. He practiced law with his uncle, William M. McAllister, in Warm Springs. He wrote articles of historical interest for many publications and also published quite a few books and pamphlets of his own, most about local history and regional travel. His granddaughter, Jean Bruns, notes that his greatest cause was the campaign to improve local roads in an effort to promote tourism. This photograph is a self-portrait.

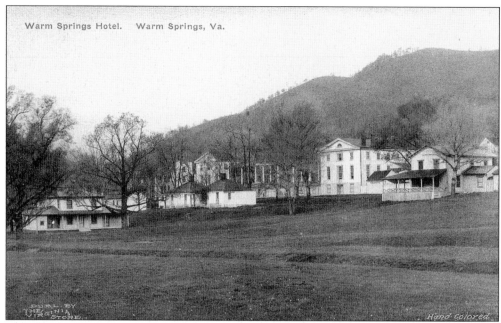

Warm Springs Hotel. Warm Springs, Va.

In its heyday, the Warm Springs Hotel far eclipsed The Homestead as the premier hotel on the Virginia Springs circuit. This 1906 postcard shows "The Warm" in its fading glory. The hotel was demolished in 1925, after its furnishings and appurtenances were sold at auction.

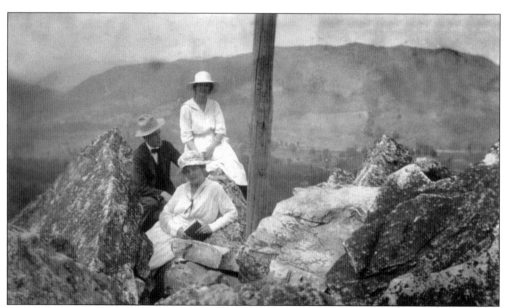

Pictured at Flag Rock in 1917 enjoying a picnic and the spectacular view across the Warm Springs valley are a Mr. Patrich, Jean McAllister (on summit), and Gertrude White, foreground, daughter of the minister at Warm Springs Presbyterian Church.

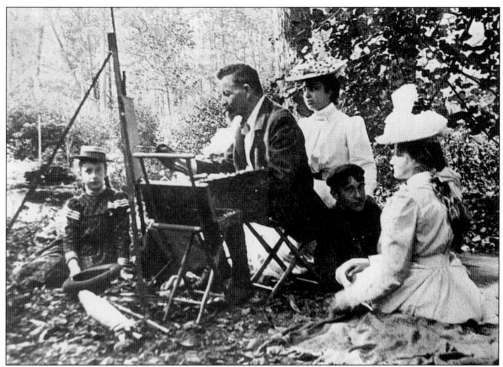

The Gibson Cottage was once part of the Warm Springs Hotel's famed "Cottage Row." Today, it is all that remains of the once-great resort. The Gibson Cottage was named for artist George Gibson, who spent summers in Warm Springs with his family. He is pictured here, at work, observed by Eliza Warwick Stephenson, her daughters Margaret and Gatewood, and her son, John W. Stephenson Jr.

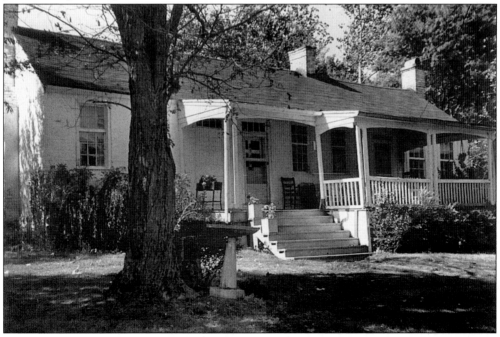

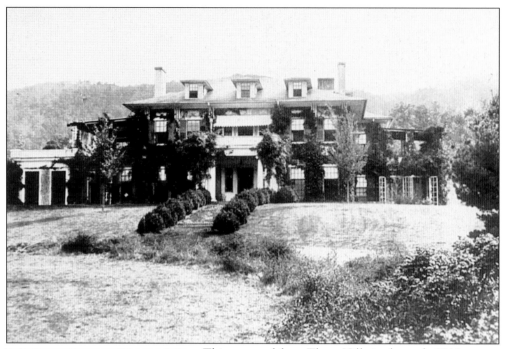

This postcard from Three Hills in the early 1940s was sent at Christmas by Eloise Johnston, sister of author Mary Johnston, who built the mansion. After Mary Johnston's death in 1936, Eloise ran the house as an inn until her death in 1943.

Author Mary Johnston's second novel, *To Have and To Hold*, written in 1899, was a blockbuster best-seller in its day. Royalties enabled Miss Johnston to build "Three Hills," a magnificent mansion high on a hill overlooking Warm Springs Gap, in 1913.

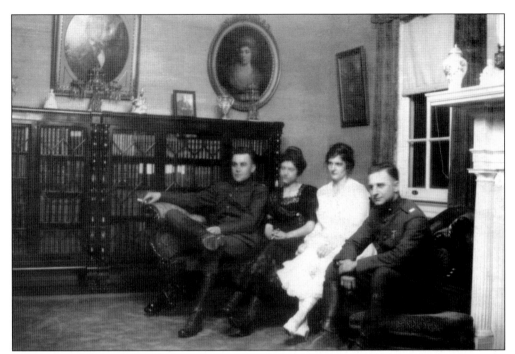

The parlor of Three Hills, the house newly built by author Mary Johnston, was the site of this party on Christmas night, 1917. These doughboys, on furlough from World War I, must have had a splendid evening with Jean Graham McAllister, third from left, and her friend.

During her writing career, Miss Johnston wrote 23 books and one play, *Goddess of Reason*. She lived at Three Hills with her siblings Eloise, Elizabeth, and Walter, until her death in May 1936 at age 65. Elizabeth and Eloise operated Three Hills as an inn until 1954; today, it again serves that purpose.

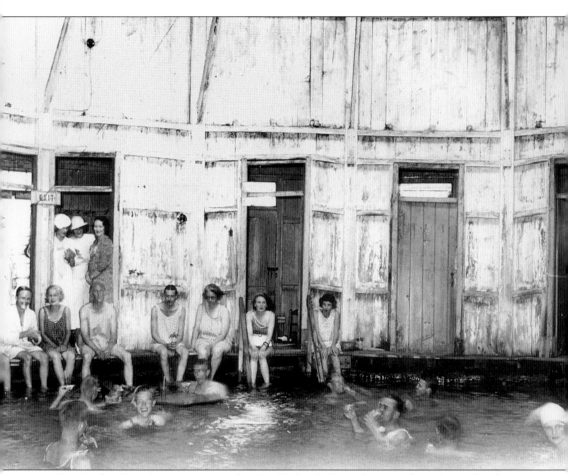

Every Labor Day for many years, the Ingalls family hosted a mixed-gender cocktail party in the men's pool at Warm Springs. In a humorous twist, the men—who normally bathed nude— donned the rompers usually worn by the ladies in their private pool. Cocktails were floated on trays in the water, and frivolity was the order of the day.

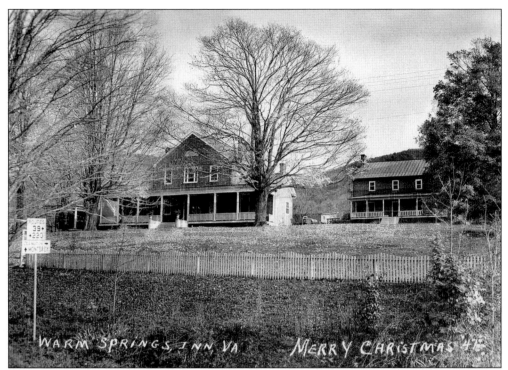

Built in 1842 and used for 66 years as Bath's second courthouse and jail, these buildings later became the Warm Springs Inn.

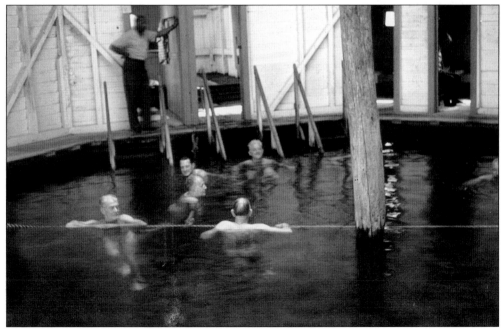

Gentlemen have always bathed au naturel in their gender-specific Warm Springs Pool. This photograph was taken in 1955. (Photo courtesy Gloria Hannan).

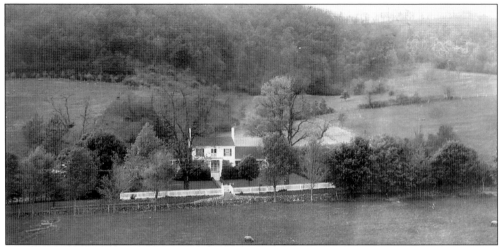

"Boxwood" was built in the 1830s by Jacob Grose. Judge Charles R. and Ellen Mayse McDannald bought it in 1872 and christened it "Aspenwold." In the 20th century, the estate now known as Boxwood was owned by Gladys Ingalls (Lady Robertson), and then A&P heir Huntington Hartford. Hartford's wife Mary Lee became the owner after divorce. She then married actor Douglas Fairbanks Jr. It is said that local ladies gathered in the gazebo at the Warm Springs Pools in order to gaze at Fairbanks whenever he emerged from the baths.

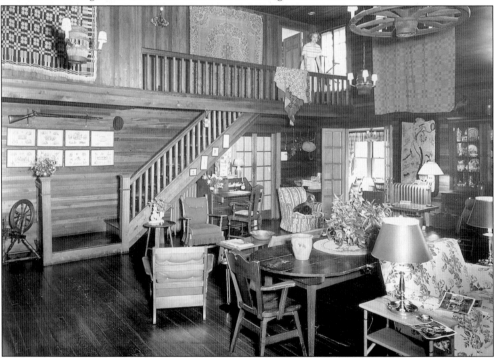

Valley View Inn, midway between "The Hot" and "The Warm," was in its heyday run by Mr. and Mrs. Harry Tschudy. Pictured here in the late 1950s is the lounge in the main lodge, which included a restaurant serving breakfast, lunch, and dinner. The Tschudys lived in a suite at the top of the stairs. The property also featured several rustic, comfortable cabins and, in the mid-1960s, a swimming pool. Today, the property is privately owned.

Baron Marcus Rosenkrantz posed for this studio photograph on March 5, 1898. The Baron met his wife, Baroness Rebie Rosenkrantz, at her parents' lovely home high atop a hill near Warm Springs. They rechristened the estate "Roseloe," and today, a motel near the site bears that name. The baron died of tuberculosis in 1933; he and his wife are buried in Warm Springs Cemetery.

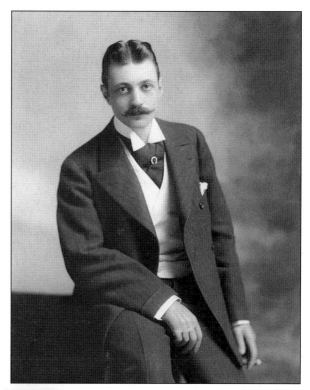

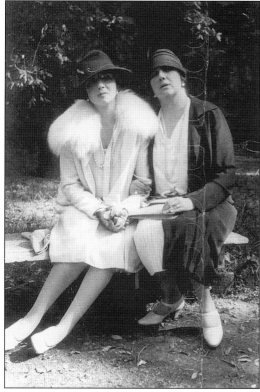

Rebie Lowe English, left, is pictured with her mother, Mrs. George Gunton, in the spectacular gardens behind the mansion built by the Guntons in 1900. Rebie later married Baron Marcus Rosenkrantz; they renamed the estate "Roseloe."

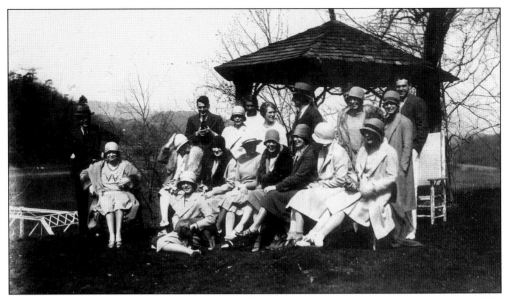

Allen M. and Ellen Reid Hirsh held this festive garden party at Fassifern Farm in 1929. The Hirshes owned Meadow Lane Farm and Folly Farm.

Orvis E. and Adella Dunham came from Saratoga Springs, New York to Bath County in 1917. From 1928 until 1947, Orvis owned the Warm Springs Inn; after selling that, he built Dunham's Motor Court, across from the old Warm Springs School. Among his avocations was an affinity for scrapbook-keeping. A dozen of these, from the 1930s through the 1960s, were bequeathed to the Bath County Historical Society.

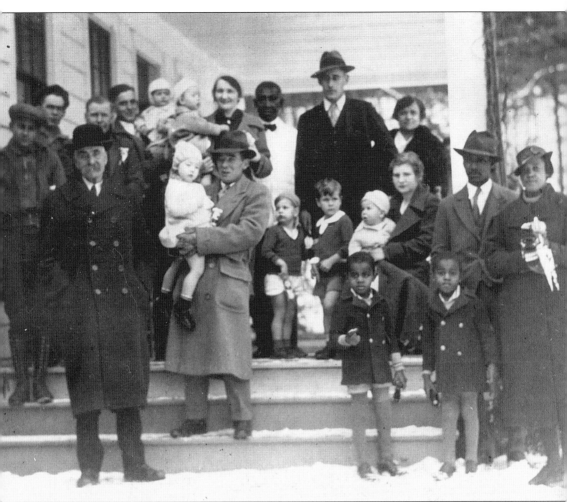

Staff traditionally gathered on Christmas Day at Allen and Ellen Reid Hirsh's Meadow Lane Farm. This 1935 photo features, from left to right, (front) James Hanna, John Hanna and daughter Susie; twins Milton and Malcom Brown; and their parents; (standing) Fern Liptrap (far left in cap); behind him, three unidentified men, one holding a child; Mrs. John Hanna and child; Charles White in white jacket; Jack Leary in fedora with his wife and three children in front; and Alice Fortune (top row, far right).

Flora Cooke Stuart, widow of Gen. J.E.B. Stuart, enjoyed summering at the Anderson Cottage in Warm Springs. She is pictured here on the verandah in 1917. (Photo courtesy Jean Bruns.)

Miss Hettie Bryan was a storekeeper in Germantown, later Warm Springs.

The Warm Springs Presbyterian Church and neighboring Christ Episcopal Church appeared quite bleak in 1900. (University of Virginia, Alderman Library photo.)

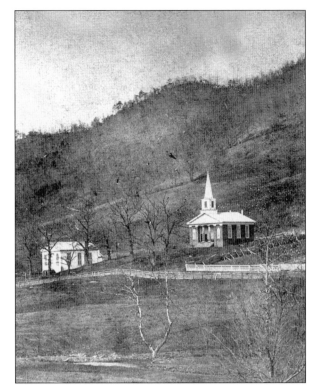

A terrific storm on April 11, 1974, nearly sounded the death knell for Christ Episcopal Church. Today, the structure stands proudly after a magnificent restoration by Mr. and Mrs. Amory Mellen Jr. in the early 1990s.

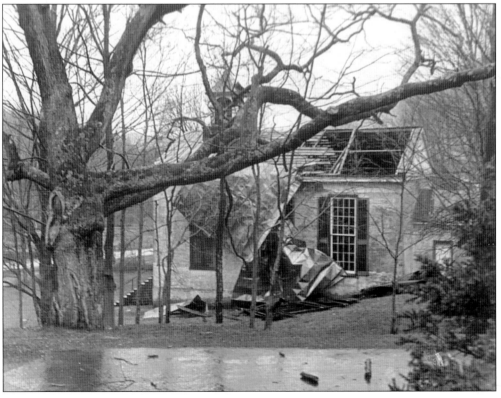

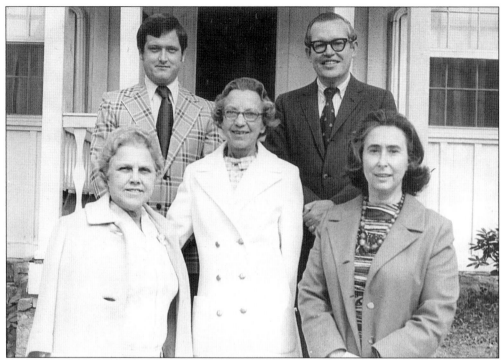

Officers and directors of the Bath County Historical Society in 1971–1972 included, from left to right, (front row) Edna Johnson Helmintoller, Carrie Bonner King, and Janis LaRue; (back row) Duncan McClintic Byrd Jr. and Hugh Sterling Gwin.

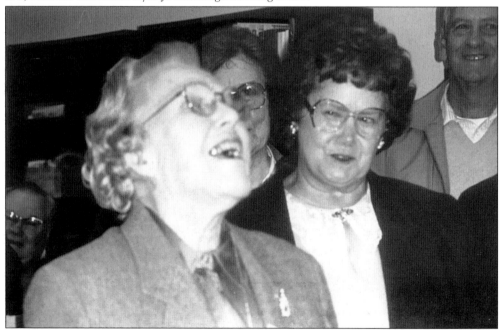

Edna Johnson Helmintoller, foreground, was delighted to see the expansion of the Bath County Historical Society in 1995. Edna was a founder of the society in 1969 and a driving force behind its collection and mission of community service. Looking on is Connie Metheny.

Two

HOT SPRINGS

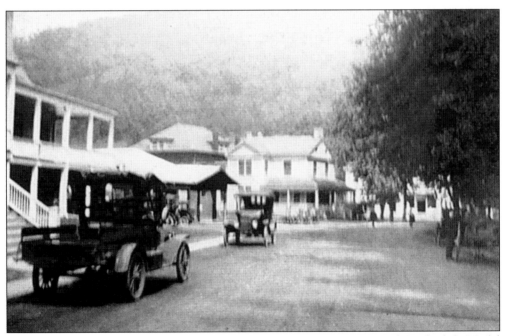

This is how Hot Springs appeared in 1917, with the Virginia House Hotel on the left, Model T Fords on the dirt street, and graceful trees lining the park-like area that later became The Homestead's children's playground.

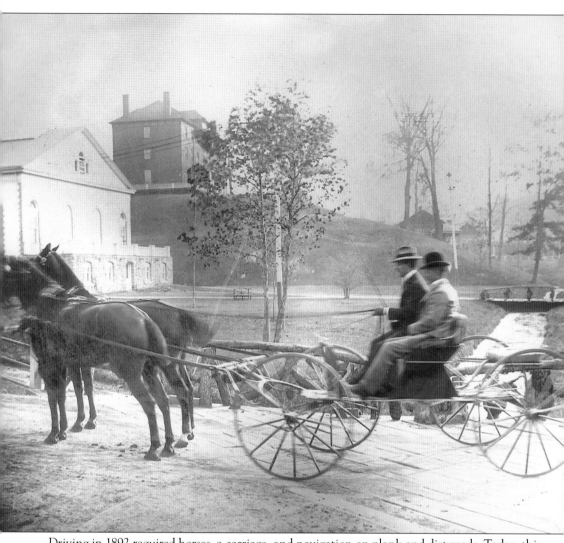

Driving in 1892 required horses, a carriage, and navigation on plank and dirt roads. Today, this is a bustling stretch of Route 220 in downtown Hot Springs.

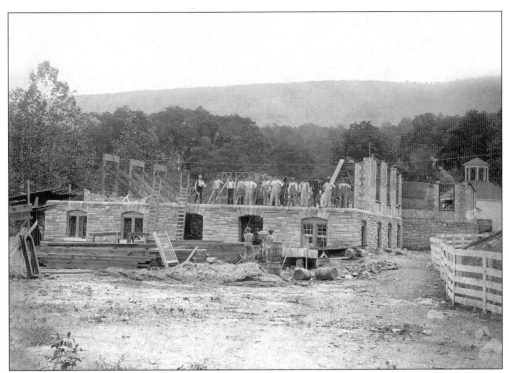

This 1892 photograph shows construction crews building the bathhouse, in use today as The Homestead Spa.

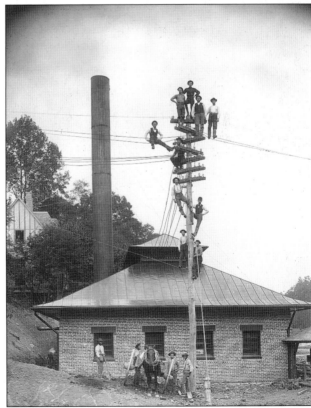

This dramatic photograph, taken by Henry Wise Hoover around 1893, shows the men who labored to build the hotel's powerhouse and bring electricity to the valley.

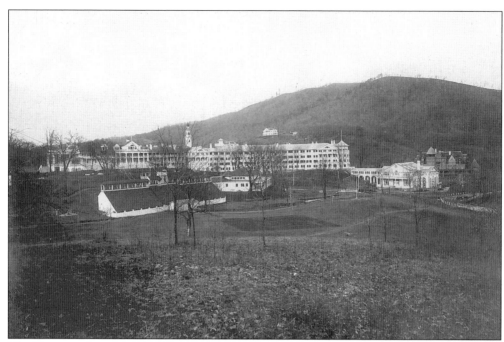

The Homestead is pictured in 1901, just before the big fire.

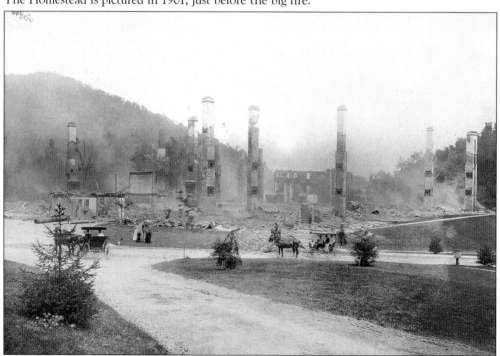

This dramatic photograph shows the aftermath of the July 1, 1901 fire that destroyed the great hotel. All guests—many in their nightclothes—and employees miraculously escaped injury. Hotel owner M.E. Ingalls led the horse-drawn fire carriages to fight the blaze. The day after the fire, Mr. Ingalls hired an architect and contractor; the hotel was open again on March 10, 1902.

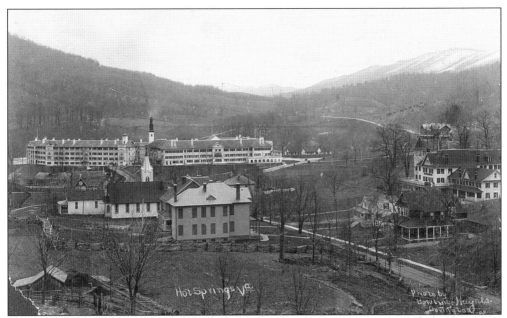

This view of Route 220 shows another view of the hotel just before the fire. The brand new Hotel Alphin is on the far right, and the Vine cottage is in the right foreground. Hot Springs Presbyterian and St. Luke's Episcopal Church are on the west side of the road, and, in the upper far right is Woodland Cottage. In 1910, Woodland Cottage was a popular gaming house with a bawdy reputation. Since the Ingalls family was promoting The Homestead as a family resort, however, they convinced Woodland's owner Thomas O'Brien to sell them the place in 1916. Today, the house is a stately private home.

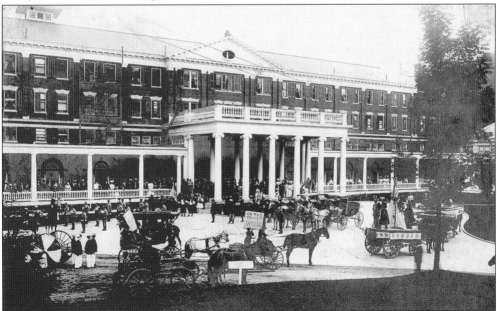

Little is recorded in local history about this Carrie Nation demonstration at the "new" hotel, around 1904. Nation campaigned across the country for temperance between 1900 and her death in 1911, wreaking havoc at saloons and other places where liquor was served.

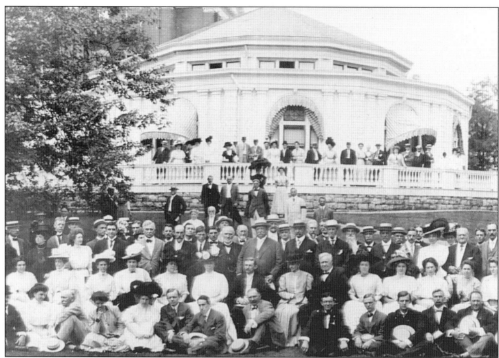

Soon-to-be President William Howard Taft, the large man in the center of the group photo, addressed the Virginia Bar Association at The Homestead on August 19, 1908. The gay and patriotic coach was part of a big parade in Hot Springs that day, honoring Taft. President Taft served from 1909 to 1913 and later served as Chief Justice of the Supreme Court.

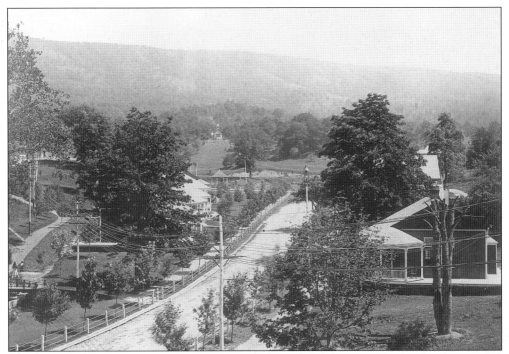

This is how Cottage Row appeared in 1895. Dr. Pole's office is in the right foreground, and the Shrine of the Sacred Heart Catholic Church, built in 1894, can be seen on the hill in the center background.

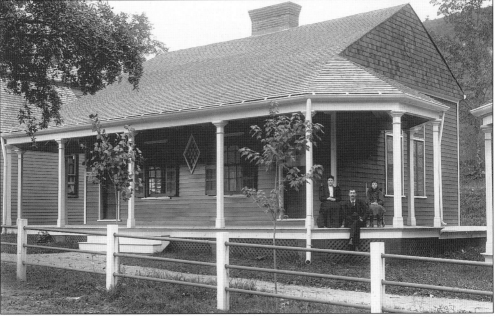

Dr. Henry S. Pole, his wife Mary Emma, and their daughter Daisy, are pictured on the porch of the hotel cottage where he had his practice in 1893. Daisy Pole married Tom Sterrett, who managed the Bath Alum hotel when Dr. Pole owned it. The Sterretts later owned the Vine Cottage Inn.

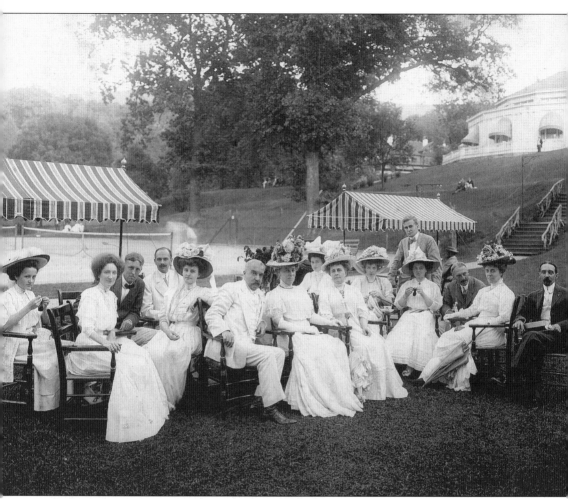

Mr. Lanier Dunn, center, hosted an engagement luncheon at The Homestead in 1905 for his daughter, Hildreth. These guests were identified in the 1940s by the Hon. Hugh S. Cummings of Hot Springs. From left to right are Miss Lanier Dunn, unidentified, George Cole Scott, unidentified, Elizabeth Dunn Buford, Mr. Lanier Dunn, Mrs. Scott (George's mother), Abbie Ingalls, Harriet (Mrs. Lanier) Dunn, Hildreth Dunn (later Mrs. George Cole) Scott, McKee Dunn (standing), Gladys Ingalls (Lady Robertson), Mr. Choteau Walsh, Mrs. Seth Barton French, and unidentified.

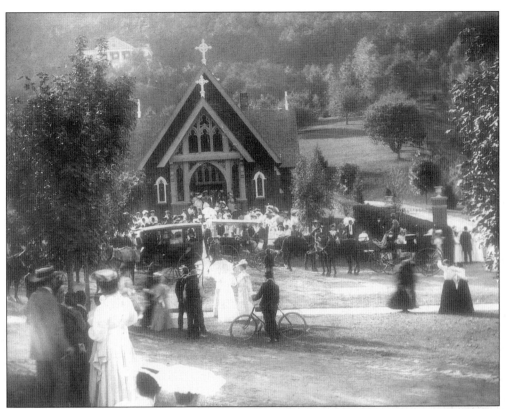

The social event of the 1905 fall
season was the September 27
wedding of Miss Hildreth Dunn
and Mr. George Cole Scott at St.
Luke's Episcopal Church in Hot
Springs. The graceful mansion built
by Seth Barton French, known today
as "Malvern Hall," can be seen in
the background.

Dr. Abbie Ingalls, daughter of Fay
and Rachel, married Dr. Kenneth
T. Calder at St. Luke's Episcopal
Church. The Calders lived in New
York and summered in Hot Springs.

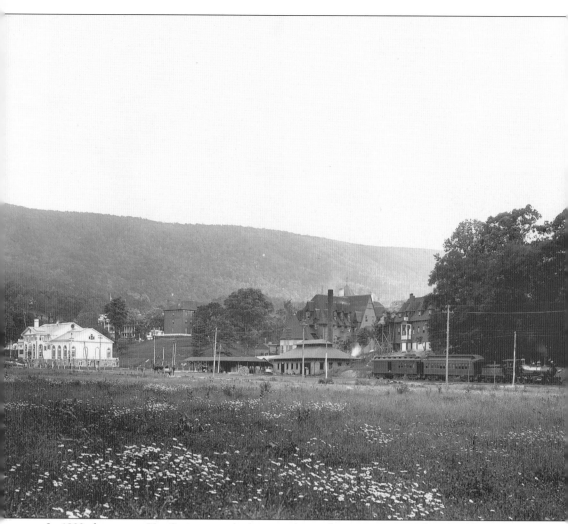

In 1893, downtown Hot Springs was little more than a flower-strewn meadow. Buildings that are today historic relics were sparkling new, including The Homestead Spa, left, the C&O Railroad station, and the Virginia House Hotel directly behind it.

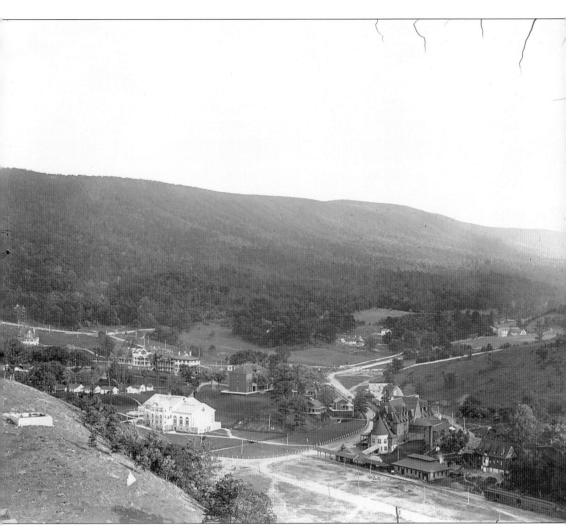

This magnificent overview of Hot Springs in 1894 shows a town dominated by The Homestead and its appurtenances. "Ingallscote," completed in 1893 as the home of the Ingalls family, appears on the far left. The bathhouse in the center was finished in 1892, around the same time as the Virginia House, on the right in front of the railroad terminal.

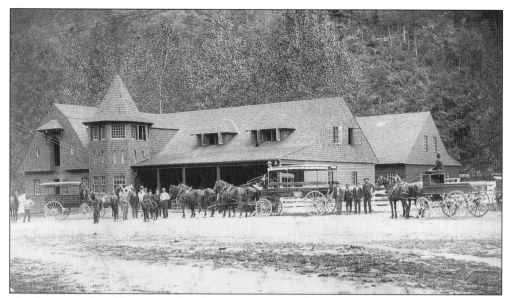

The Homestead Stables were a bustling place on March 15, 1893, when local photographer Henry Wise Hoover took this picture. Livery carriages such as the one in the center ferried guests from the train station to the hotel.

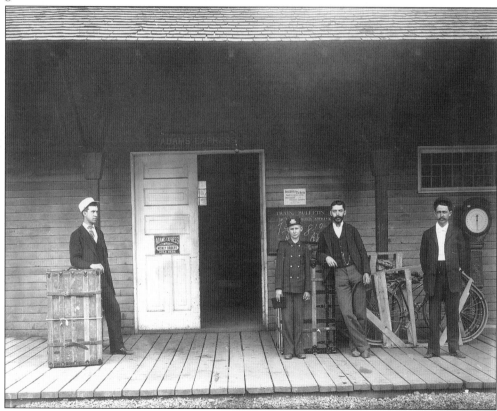

The Adams Express Office, at the train station in Hot Springs, was the town's communication hub in the 1890s.

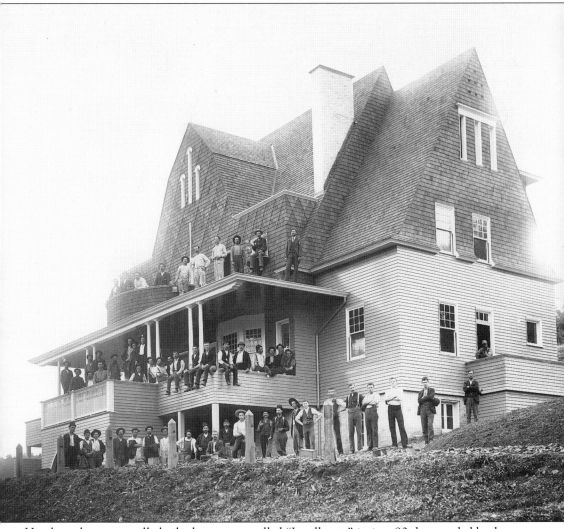

Hotel employees actually built the cottage called "Ingallscote" in just 90 days, probably about 1893, when massive building projects abounded on The Homestead environs. The Ingalls family, which owned and operated the hotel under Virginia Hot Springs Company for 100 years, lived here, on a hill overlooking the main entrance. Later, Ingallscote was demolished and "Fairacre" was built in its place. Today, the site is a parking lot.

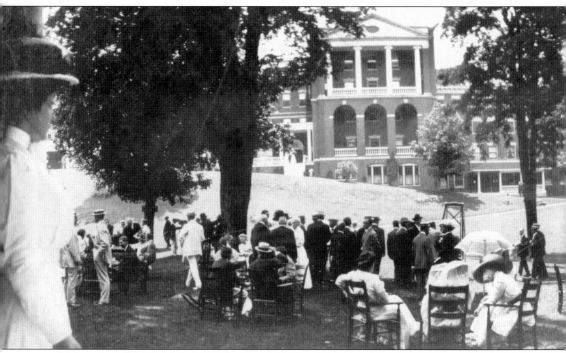

The J.T. McAllister photograph above, entitled "On the Lawn at Hot Springs," was probably taken around 1914. Before the Community House Hospital could be built, funds had to be raised. This was done with a Social Supper and Street Fair in Hot Springs, below. Gladys Ingalls established the Visiting Nurse Association in 1913, to bring health care to isolated farms and communities. It was the first Red Cross Rural Nursing Association in America. The

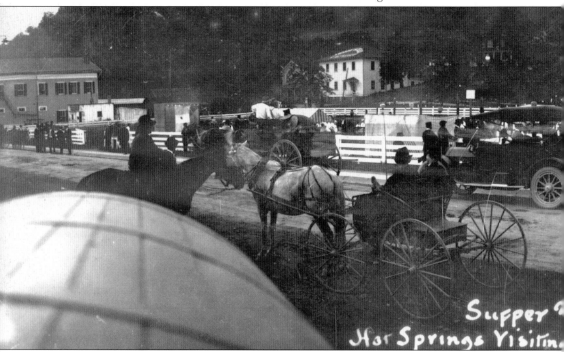

Supper ʼ
Hot Springs Visitin.

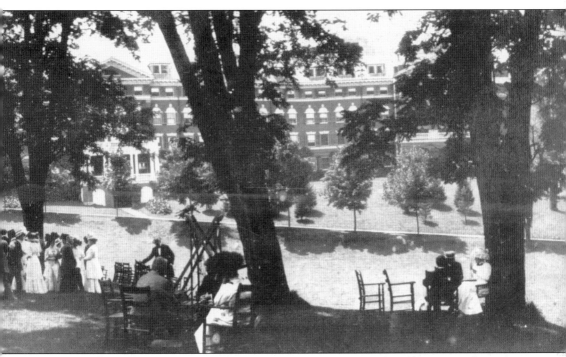

nurses reached their patients using a buggy pulled by a horse named "Old Joe." People in the community provided the food for Gladys Ingalls's Social Suppers, and the whole countryside was invited. The August 15, 1914 Supper and Street Fair here was the first of these annual events, which lasted into the early 1960s.

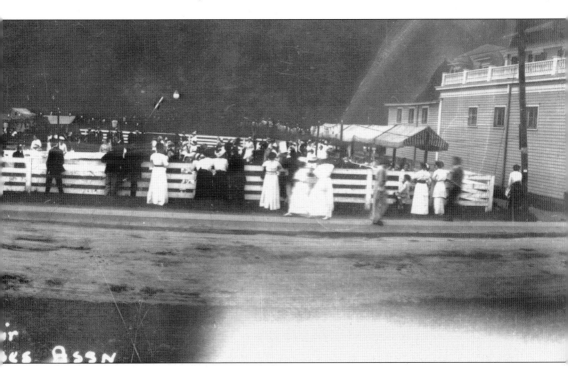

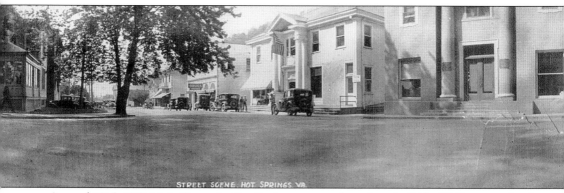

STREET SCENE, HOT SPRINGS, VA.

Around 1915–1917, Main Street in Hot Springs appeared much as it did in 1963, except for the early automobiles. In later years, Dr. Donald S. Myers used the house on the right as an office; today, it houses several shops.

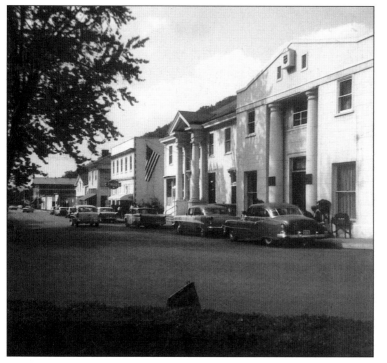

This was Main Street, Hot Springs, in 1963. The Bath County National Bank in the foreground is now Sam Snead's Tavern. The adjacent Hot Springs Post Office was razed after the new building, further down the street, was completed in 1967.

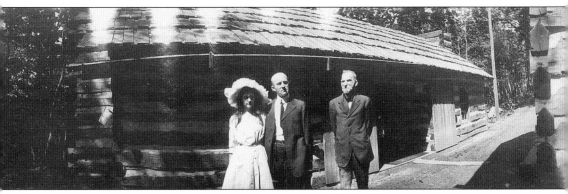

Photographer, attorney, writer, and man-about-town Joseph T. McAllister (center) ran a popular tearoom called Daniel Boone's Cabin, near the hotel. He is accompanied in this self-portrait by his daughter, Jean Graham McAllister, and his uncle, William M. McAllister.

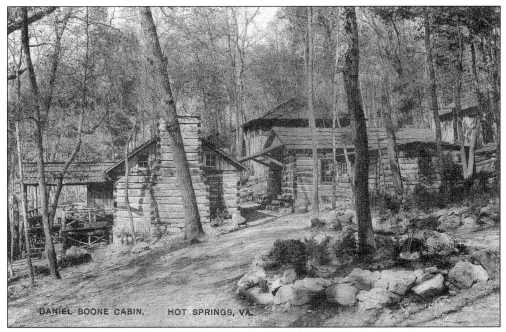

DANIEL BOONE CABIN, HOT SPRINGS, VA.

An overview of Daniel Boone's Cabin was featured in this 1914 postcard.

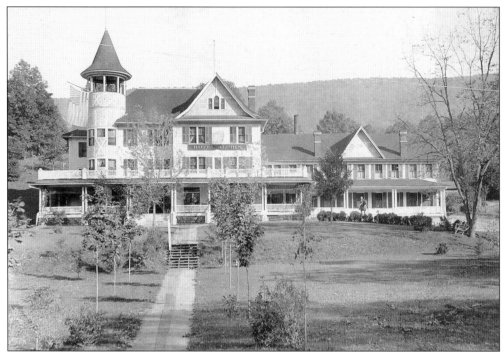

The Hotel Alphin had a commanding presence in Hot Springs, but it was open less than 10 years before being destroyed by fire in 1910. The Alphin, which could accommodate 125 guests in rooms with electric lights and telephones, sat north of what is today the entrance to The Homestead. After his hotel burned to the ground, owner Lacy Alphin developed the Bath Tavern, just west of Hot Springs. That establishment was flooded in 1913. After that, Mr. Alphin and his third wife, Ida Warren, built a three-story stucco house that stands today, beside Vine Cottage Inn.

J.T. McAllister built the Vine Cottage as a private residence in 1900. Today, it is an inn, along Route 220 just south of The Homestead.

54

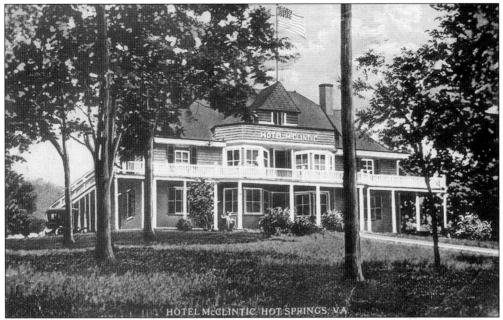

The Hotel McClintic sat on a knoll in what is today Mitchelltown. It was owned and operated by Jacob H. McClintic, whose wife, Sallie Ida, was a daughter of Judge James Woods Warwick of Warwickton in Hidden Valley. Two McClintic daughters, Mrs. Ida Evans and Mrs. Marguerite Northern, were well-known local businesswomen; they lived at "Widow's Knob," the brick house on a hill opposite the site of the old hotel.

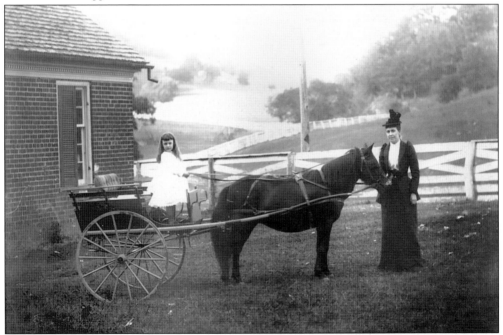

Little Marguerite McClintic (Northern) lived a charmed life in Hot Springs near the turn of the 20th century. She is sitting pretty in her carriage, while her mother, Ida Warwick McClintic, makes certain the pony doesn't begin prancing.

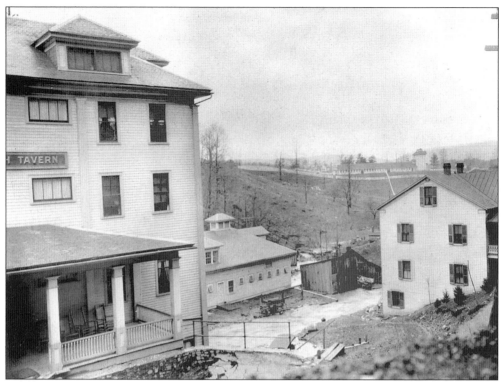

The big flood of March 27, 1913, overran the Bath Tavern and its surrounds. In the distance is the first Homestead Dairy.

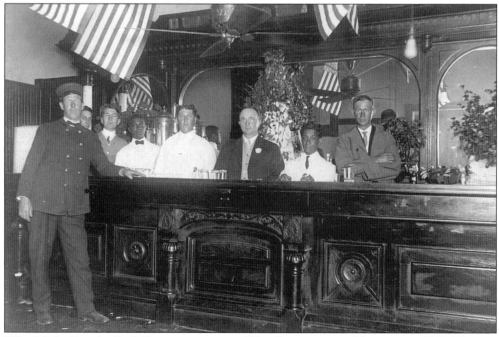

"The Market" at the Bath Tavern, just west of Hot Springs, started business in 1907. The site later became Criser's Livery, and the buildings still stand.

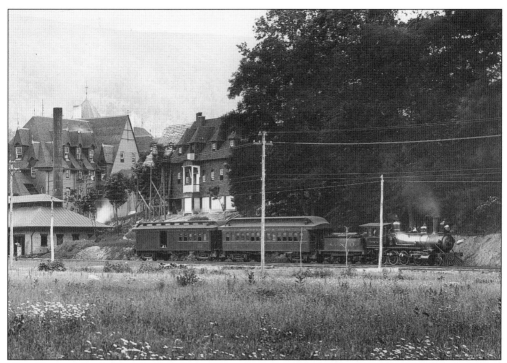

The Chesapeake & Ohio Railroad was as much responsible for the success of The Homestead as its famed hot springs water. In 1893, the Virginia House Hotel had just been constructed (left), and the site of today's busy shops was just a field of flowers.

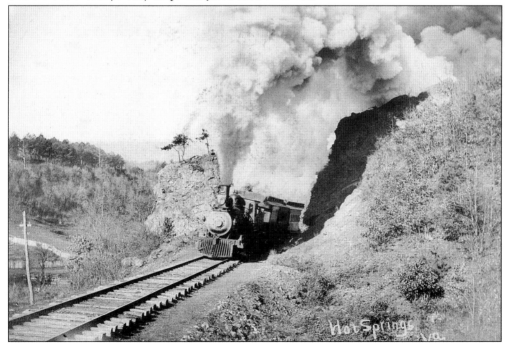

Photographer J.T. McAllister entitled this one "Comin' Round the Mountain." It shows the C&O steam engine rounding a bend along the Hot Springs-Covington route.

Rachel (Mrs. Fay) Ingalls and her daughter Abbie were photographed at The Homestead prior to 1939. That fateful year, Rachel and her prized blue roan, "Jumping Jack," took a nasty fall during a hunt; the accident left Mrs. Ingalls badly crippled. She died in 1966; Pegasus, the mythical flying horse, is carved on her tombstone.

The entrance to Hobby Horse Farm, near The Cascades, is seen as it appeared in winter, late 1940s. Fay Ingalls and his wife Rachel, an avid horsewoman, bought Hobby Horse in 1926. The Ingalls lived at The Yard, which they built in 1925. At Hobby Horse, they "bought a stallion and some blood mares, and were in the horse business," Fay wrote in his book, *The Valley Road*.

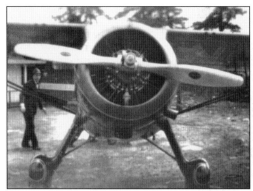 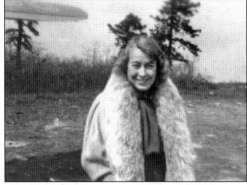

David Ingalls, the man who brought aviation to Hot Springs, was a World War I flying ace. At left, Mr. Ingalls walks to his plane at what is today Ingalls Field. At right is Lela Vardell, later Mrs. T.K.Ellis. These photographs were taken in 1937.

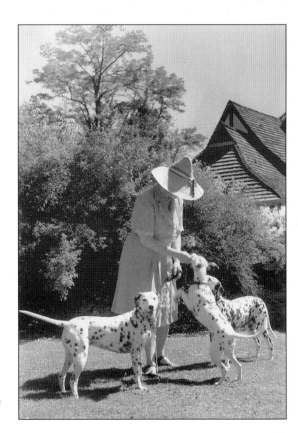

Rachel (Mrs. Fay) Ingalls plays with her pampered prize Dalmatians at "The Yard" in Hot Springs.

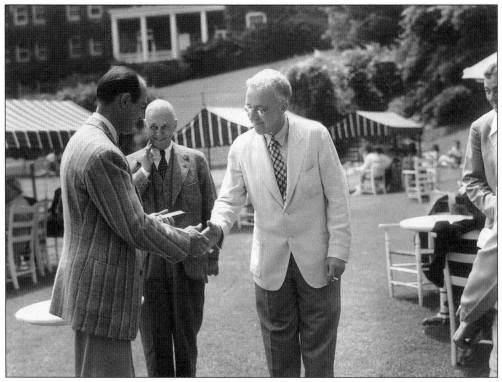

Fay Ingalls, right, president of Virginia Hot Springs, congratulates golfer Sam Snead, left, on the Casino lawn in the early 1950s.

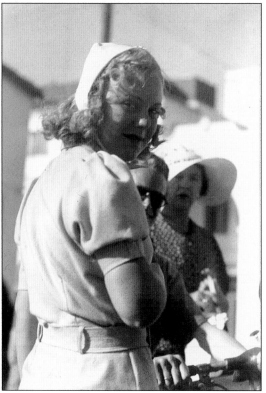

The world's first celebrated figure skater, Sonja Henie, visited The Homestead around 1933. The Norwegian-American won Olympic medals in 1928, 1932, and 1936.

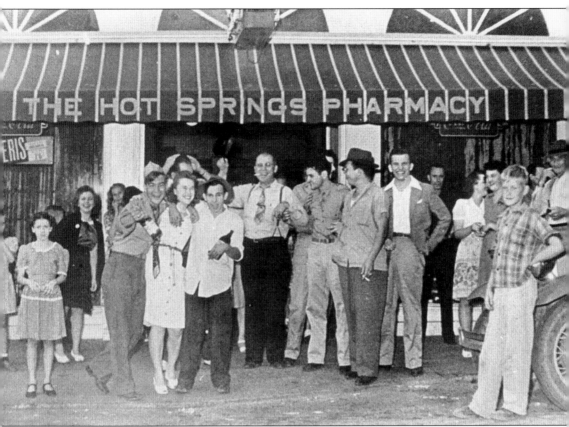

The day World War II ended was cause for an ongoing celebration in downtown Hot Springs. These revelers include Marie Terry Wiley, the young woman in the center supporting a soldier; Dick Adams, clutching bottle, to the right of Ms. Wiley; Lacy Ford, center, in tie, suspenders, cigarette, and big grin; Pat Clemons, the young boy in plaid shirt in right foreground; and Audrey Armstrong, in dark dress behind Clemons.

Lanier Dunn, patriarch of the Dunns of Dunn's Gap, sent this autographed greeting card in January 1898.

Harriet (Mrs. Lanier) Dunn.

Miss Elizabeth Dunn, daughter of Lanier and Harriet, of Dunn's Gap, married Mr. Sydney Buford of Richmond.

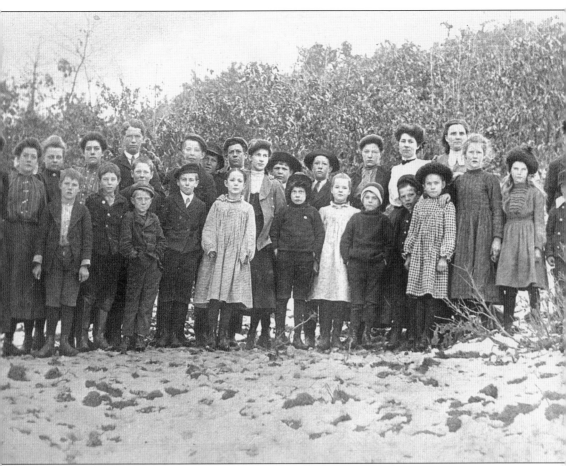

These students attended the first Thomastown School in 1904–1905. They include, from left to right, (front row) Dewit Layman, son of John Layman; two unidentified; Charlie Layman, standing behind boy with cap, son of Ben Layman; Harry Page; Susie Layman (Bowers), daughter of Ben Layman; unidentified; Clara Helmintoller; three unidentified children; Icie Layman (Tomlin), daughter of John Layman; Edith Layman; and unidentified; (back row) Mamie Green; Jessie Layman (Athens), daughter of John Layman; Piney Davis (Smith); Bettie Layman (Milleron), daughter of John Layman; Dowe George, son of Wesley George; Andrew Layman, son of Ben Layman; Holmes Bell (hat on, peeking through); Curtis George, son of Wesley George; Della Page (Campbell); Frank McElwee, son of Etta McElwee; two unidentified chidren; unidentified teacher; Hulda Jenkins; and Crawford Bogan.

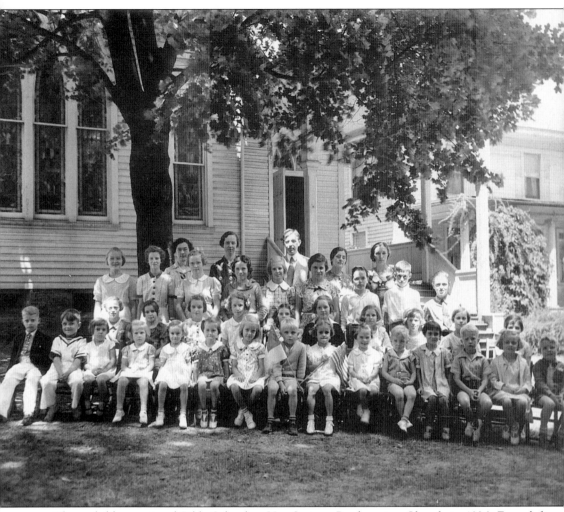

These children enjoyed Bible School at Hot Springs Presbyterian Church in 1936. From left to right are (first row) Winfred Deaner, Bruce Johnson, Nancy Pace, Nancy Bonner, Nancy Donovan, Emma Shelton, Scotty Bonner, Ben Alan Johnson, Charlotte Burns, Dorothy McElwee, Fred Shelton, Jean Stinnett, George Bonner, Alice Lane Pace, and Richard C. Johnson; (second row) Irene Deaner, Elizabeth Andrews, Virginia May, Eleanor McElwee, Elizabeth Marshall, Nancy Criser, Mary Margaret Smith, Betty Kincaid (?), Garnett Smith, and Bebe Kincaid (?); (third row) Pearl McElwee, Dorothy Deaner, Georgia Helmintoller, Janie Bogan, Anne Challender, Marie Andrews, Cyril Kincaid, unidentified, and George Allen; (fourth row) Anna Robinson, Charlotte Taylor, Rev. George W. Oldham, Mrs. Oldham, and Marguerite Challender.

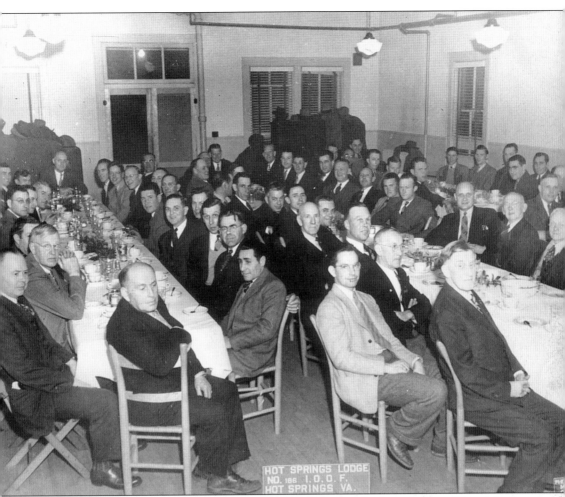

The Hot Springs Odd Fellows hosted a joint meeting with Alleghany Lodge #23 in March 1947. Pictured from left to right at table one are Roy Bowers at the head of the table, Robert M. Mustoe, Orvis E. Dunham, Duncan M. Byrd Sr., three unidentified members, Henry Lester, unidentified, Eldon "Mickey" Robertson, Robert Grose, and Alvin Brinkley; (foot of table one) unidentified, Forrest Arehart, Harry Coffman, Ralph Layman, Frank Burns, and Erbie L. Conner Jr.; (behind them and to the end of the table) J.W. Switzer, Haller Thomas, Mason Martin, George L. Taylor, Andrew Cleek, Fay Bussard, and Gratton May. At table two, from left to right, are William McMunn, Carl Harouff, Bernie Griffin, Charlie Armstrong, unidentified, Sam Snead from Covington, unidentified, William Bonner, Arnold Keyser, Norvelle Keyser with face turned, the top of Julian Griffin's head, Charlie Hodge, Eldon Crowder, Woody Bussard at the foot of the table, Ralph Bussard, Willard Hicks, Henry Reid, unidentified, Everett Reyns, unidentified, Harrison M. Hicks, Leland "Cocky" Bowers, Ralph Pace, Henry Carter, and P.C. Helmintoller Sr. At table three are Carmi Neff, Arnold Woodzell, Barrett Loving, Mac Harouff, Floyd Carpenter, unidentified, Harry Shumate, Waldo Neff, John Harouff, Roy Terry, Tommy May Sr., and Carl Peery.

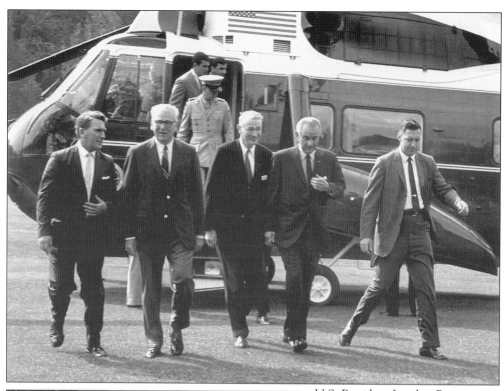

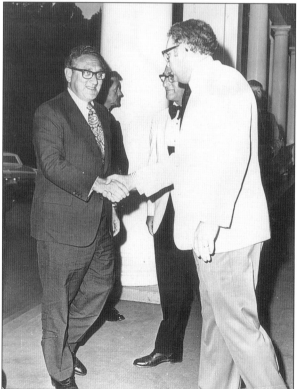

U.S. President Lyndon Baines Johnson's helicopter, "Marine One," landed on The Homestead golf course in 1968. President Johnson was here to address the Business Council, which convened at the hotel twice each year. From left to right are Homestead chief of security David McCollum Jr., Homestead general manager Thomas J. Lennon, unidentified, President Johnson, and a U.S. Secret Service agent. (Photo courtesy Margo Oxendine.)

U.S. Secretary of State Henry Kissinger visited The Homestead on July 27, 1974. He was greeted at the main entrance by hotel manager William Worsham, right, and chief of security David McCollum Jr., center. (Photo courtesy Margo Oxendine.)

Three

HEALING SPRINGS

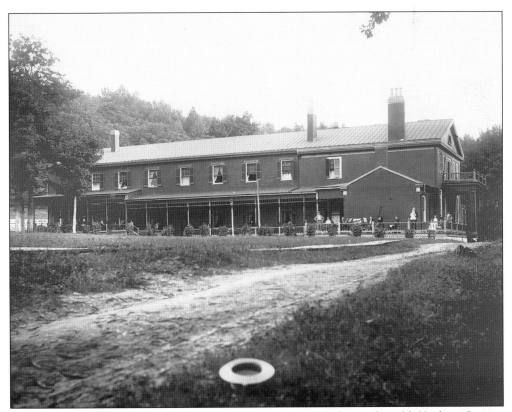

This photograph, taken by Henry Wise Hoover in 1893, shows the old Healing Springs Hotel, later the site of the Cascades Inn. The Healing Springs Hotel was used as a hospital during the Civil War, and then as a girl's finishing school. Note the photographer's hat in the foreground.

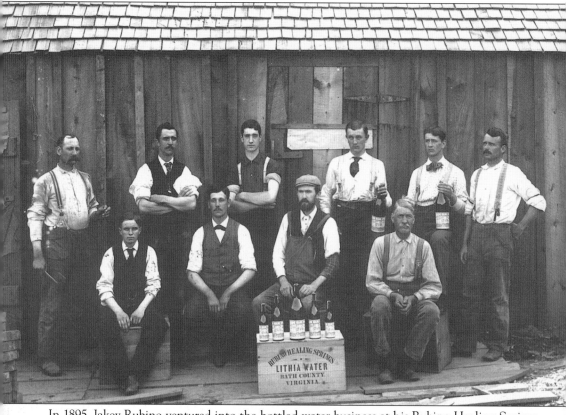

In 1895, Jakey Rubino ventured into the bottled water business at his Rubino Healing Springs. This enterprise was short-lived, although 100 years later, the bottling of lithium water might have been quite lucrative. Pictured at the bottling plant from left to right are (front row) Fred Chaplin, Harry Williams, unidentified, and George Jackson; (back row) Ben Layman, Harry Snead, unidentified, Will Smith, unidentified, and Newt Williams.

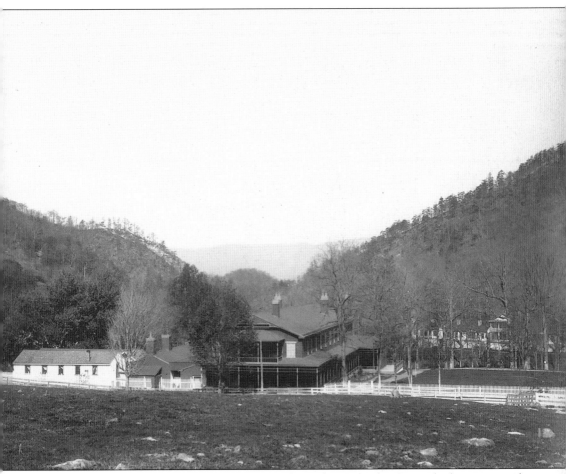

Shown is the Healing Springs Hotel in 1895, later the Cascades Inn, which was owned and operated by The Homestead under Virginia Hot Springs, Inc. The building in the center still stands, although it did undergo extensive renovation. The Cascades Inn has been closed since 1993.

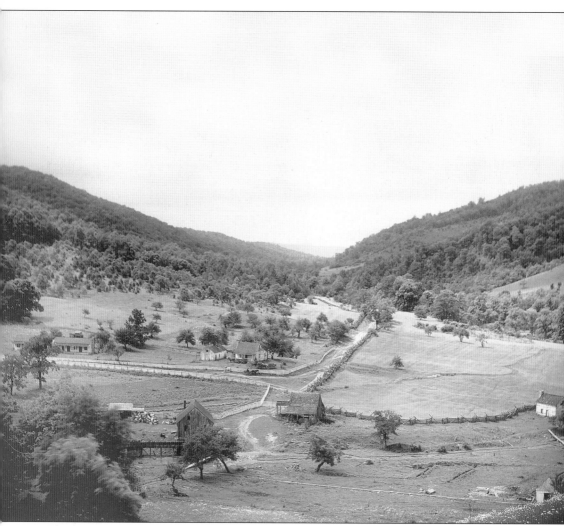

This attractive, sprawling farm belonged to Benjamin George and Mary Elizabeth Jackson in the mid-1800s. One of the Jackson daughters, Cacydell Cuva (born 1877), married William Clark Johnson. One of the Johnson daughters, Edna, married Ralph Helmintoller. Edna was one of the founders of the Bath County Historical Society. The Jackson Farm later became the Cascades Golf Course, one of the nation's finest.

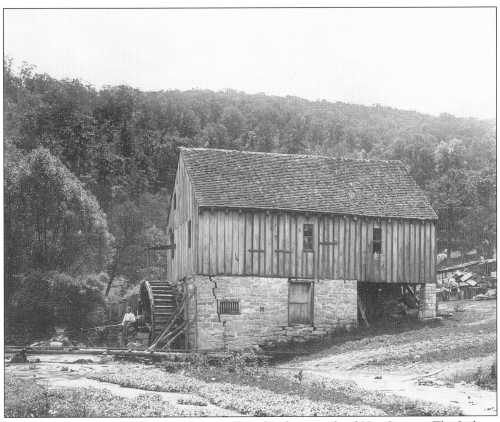

Benjamin George Jackson operated this mill on his farm south of Hot Springs. The Jackson farm and the adjacent Thompson farm today comprise The Cascades Golf Course.

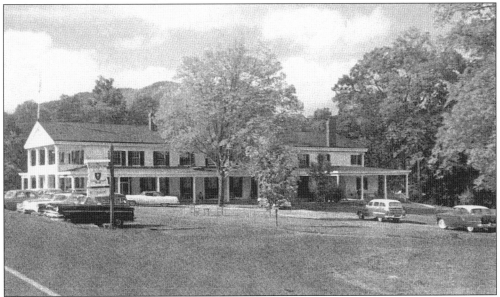

The Cascades Inn was a popular adjunct of The Homestead in the 1950s, when this postcard was photographed. The Inn closed in 1993.

This was the home of Bernard "Barney" and Selena Bowyer Johnson in Cedar Creek. Barney and his son Robert David "Dick" Johnson owned the Cedar Creek Milling Company. It was located where the toolhouse of the Lower Cascades Golf Course is today.

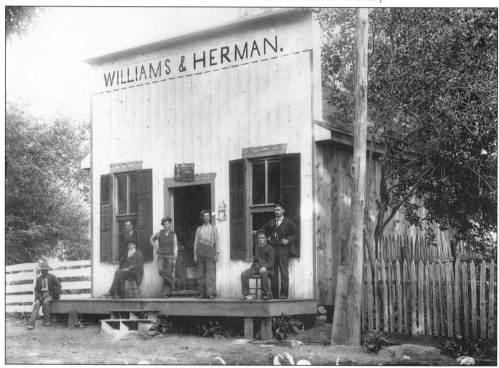

The Williams & Herman Store, operated by Elisha Williams and Harry Herman in the mid-1800s, was a hub of activity and a good place for sharing news and gossip. Those identified in this photo are, from left to right, John Underwood, Mr. Snead Keyser with long white beard, and, at far right, Harry Herman. The store was in Healing Springs, across from the Baptist church.

Marion, left, and Wallace Hoover.

James and Minnie Hoover.

Effie and Carrie Hoover.

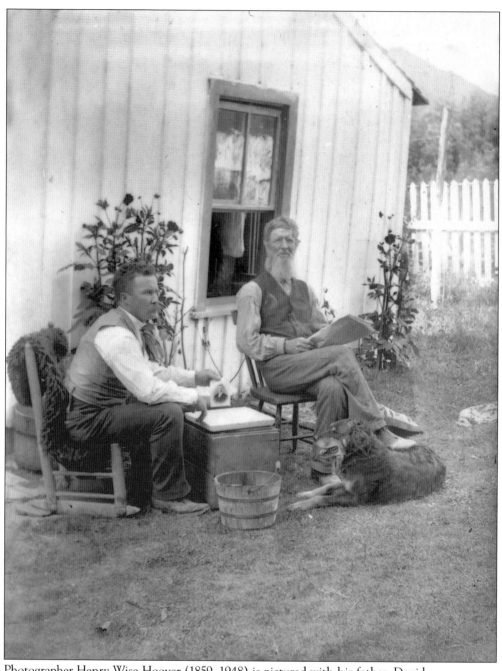

Photographer Henry Wise Hoover (1859–1948) is pictured with his father, David.

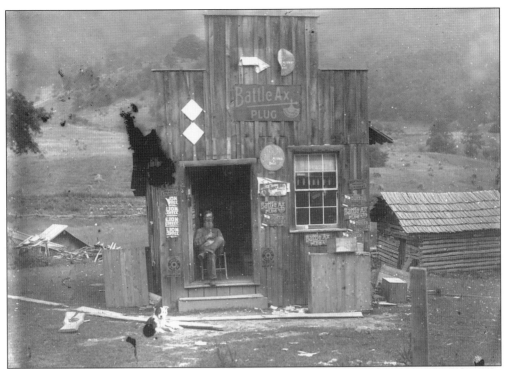

David Hoover is pictured in 1893, at his store in what is today the community of Carloover. This photograph, taken by David's son Henry Wise Hoover, is one of 2,000 glass negatives purchased at a Carloover auction in the late 1960s by Elaine Madlener. The original store was razed in 1897, and the new one built in its place. Both stores also served as the Carloover Post Office, with a Hoover as postmaster until 1956.

Ruth Hoover Lide, born February 10, 1898, was the daughter of well-known Bath County photographer Henry Wise Hoover and his wife, Annie. The Hoovers were the "founders" of the Bath community known today as Carloover.

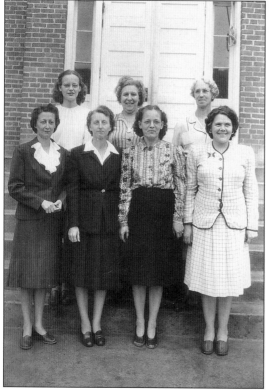

The Junior Class of Ashwood School, 1926–1927, included from left to right, (front row) Mary Belle McGlamery, Reba Chaplin (Hepler), Margaret Byrne, Mary Jane Jordan (Connor), Claurice Liptrap (McLaughlin), and Camilla Dunham (Karl); (back row) Ralph Helmintoller, Olga Lamb (Laughrie), Carolyn Snyder (May), Josephine Stephenson (Woodzell), Dorothy Cleek, Sadie Tulloh, and Eugene Hart. This class was the first to graduate from the "new" Valley High School in Mitchelltown in 1928.

These ladies were well known to all who attended Ashwood School in the 1940s. This photo, in 1945–1946, includes from left to right, (front row) Mrs. Ada Belcher Paige, Mrs. Mary Wiley Simpson, Mrs. Una Pointer Waskey, and Mrs. Vina Hepler Shaver; (back row) Miss Rachel Kelsey, Miss Mary Susan Revercomb (principal), and Miss Flossie Conard Rowe.

Four

MILLBORO AND EASTERN BATH

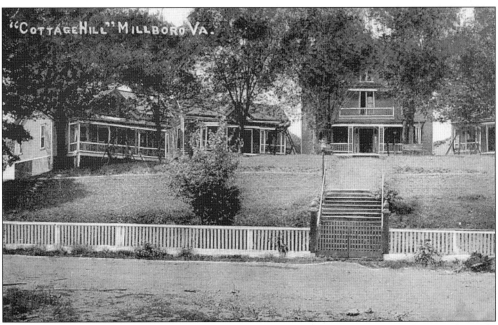

Cottage Hill in the center of the village of Millboro was quite the bustling place in the early 1900s, when it was operated by J.W. Warren. Many of these buildings stand today and are privately owned. The big hotel on Cottage Hill served passengers who disembarked at the Millboro train station across the road.

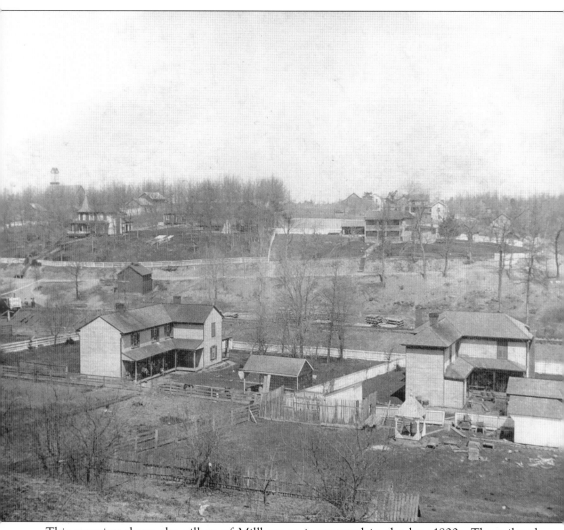

This overview shows the village of Millboro as it appeared in the late 1800s. The railroad tracks, running through the center of the picture, provide a perspective for comparison with the village today.

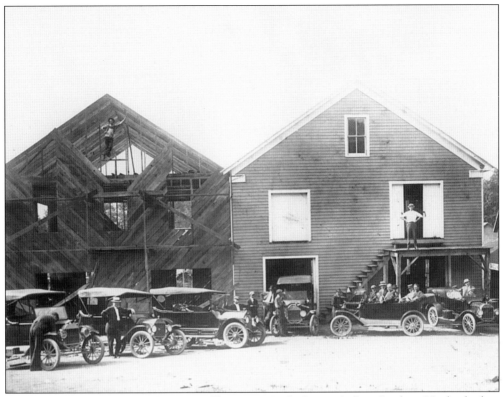

Forrest Hepler's Ford dealership in Millboro was Bath County's first. In fact, Hepler had to expand his garage just a few years after building it, due to the overwhelming popularity of Henry Ford's "horseless carriage." Hepler's was located across the railroad tracks from the hotel, store, and train station.

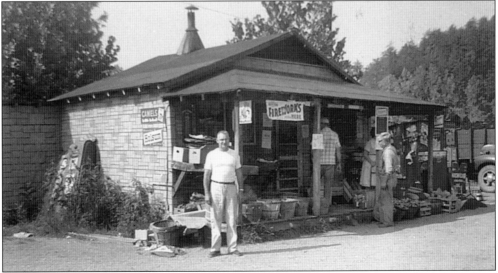

In 1956, Deitz's Store in Millboro Springs was a humble structure. Harold Deitz, pictured, and his wife, Charlotte, soon built a bigger, more modern store, where they held forth daily for 50 years.

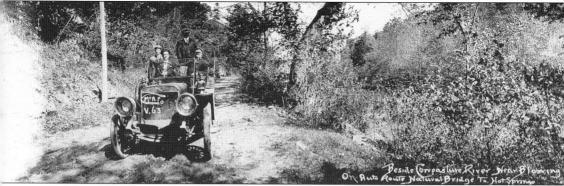

This photograph by J.T. McAllister shows how the modern Route 39 east along the scenic Cowpasture River appeared in 1917. The "blowing cave," which reversed direction in hot and cold seasons, was destroyed by blasting when the highway was widened and paved. The delightful motor party photo shows Kenneth Williams and sisters Virginia Cauley (Webb) and Julia Cauley (Toney) near what is today known as Windy Cove.

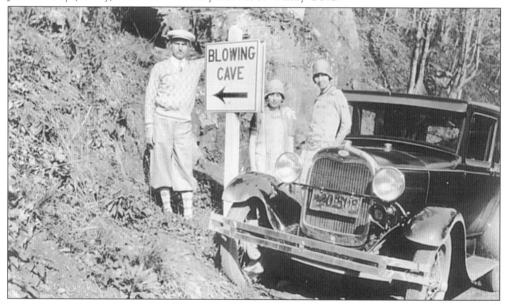

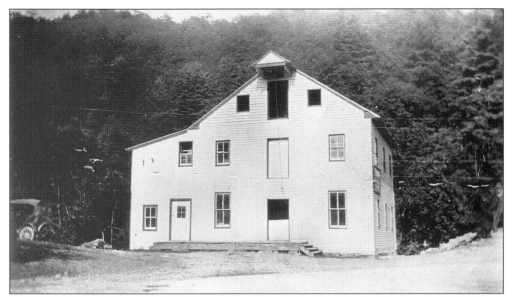

Lowman's Mill, along Route 42 near Millboro Springs, was established in 1829 and has been owned by the Lowmans since 1869. It generated the first electrical power for the Millboro area from 1913 to 1937. Although the dam remains, an electrical fire destroyed the mill on Thursday night, May 22, 1959. Charles Lowman Jr. and his wife, Minnie Hickman Lowman, owned and operated the mill at that time. She was the daughter of Lewis and Martha Jane Hickman.

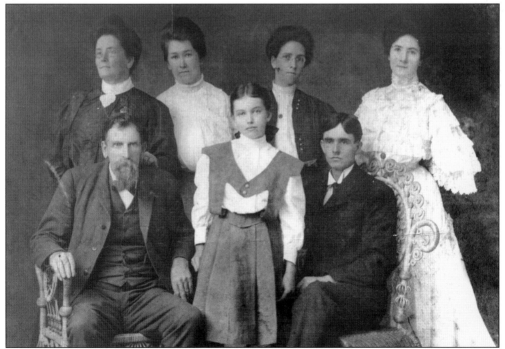

The Lewis Hickman family included, from left to right, (front row) Mr. Hickman, Carrie Wilmore (mother of Lee LaRue Tennant), and Albert McDill; (back row) Mrs. Lewis Hickman and her daughters Myrtle, Mattie and Lula, who married Mr. McDill. (Photo courtesy Linda Tennant Weiss.)

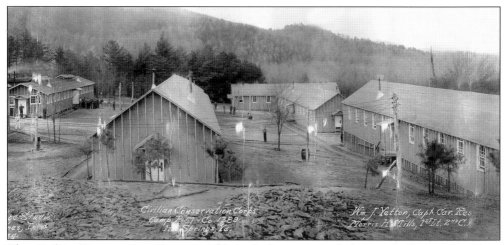

The Civilian Conservation Corps put able-bodied men to work during the Depression. From those efforts, Virginia's State Parks came into being, along with many highway improvements. This CCC camp was along Route 39 at Mountain View. One cabin still stands and is home to the LaRue Hunt Club.

The Sitlington house, known as "Mimic" in 1935 when this photo was taken, is 18th century stone, one of eastern Bath's oldest and finest.

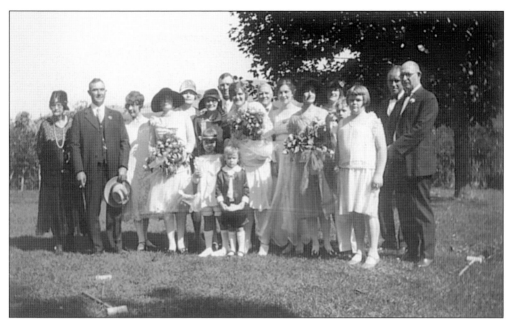

This September 22, 1928 wedding at Riverside Farm in Williamsville featured bride Lina Douglas Ervin and groom Allen Rector, center; ringbearer Robert McAllister Ervin and flower girl Rebekah McClintic (Tankersley), front; Ann McClintic (Lockridge), far right, front; James Gray Ervin, boy behind Ann; the bride's twin sister, Mary Julia Ervin Pierson, in black hat with pin, behind James Ervin; mother of the bride, Lina Glendye Ervin and, behind her in white hat, Jane Ervin McClintic, mother of Ann and Rebekah; Margaret Ervin Carson, front row with bouquet and black hat; and the groom's brother, Robert Rector, hat in hand.

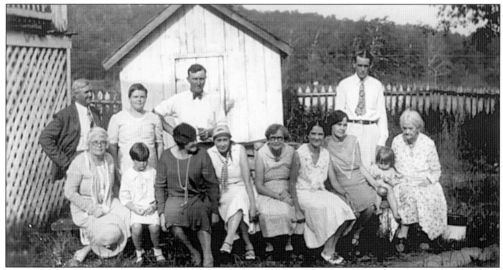

This 1935 family gathering, at Wilson Springs near Goshen Pass, shows the McClintic-Ervin-Rector family more than a decade after the wedding. From left to right are (front row) Jane Ervin McClintic, Rebekah McClintic (Tankersley), Douglas Ervin Rector, Willie Ervin McCue, Margaret Ervin Carson, Willie's step-daughter Jane McCue, Minnette Erwin, her daughter Patricia, and Lina Glendye Ervin; (back row) Robert G. McClintic, Ann McClintic (Lockridge), Allen Rector, and Guy Erwin.

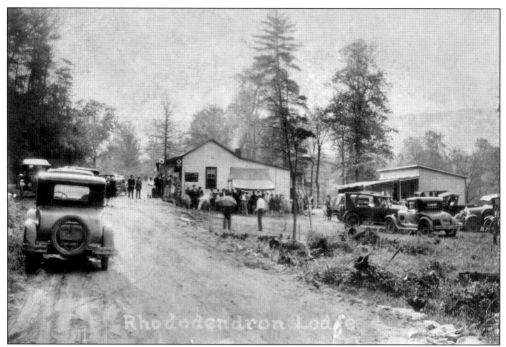

The Rhododendron Lodge was a popular roadhouse, as evidenced by this photograph taken in late fall 1929. Shortly thereafter, on December 7, Bath County Sheriff Charles A. Gum was shot and killed while attempting to quell a disturbance here. (Photo courtesy Jim Tennant.)

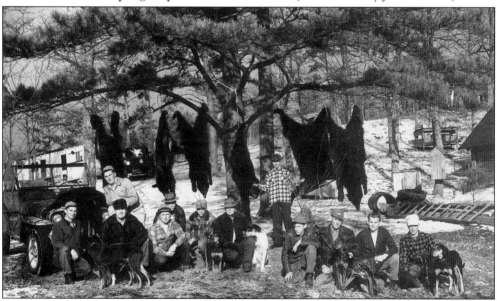

These bear hunters were pleased with their success in the woods at Jordan's Top in 1950. Raymond Doyle's place near the top of Warm Springs Mountain was a rustic recreational spot famed with sportsmen from across the country. This hunt, though, was for local boys. From left to right, they are Tommy Wood, Jim Tennant (standing), C.M. Hester, Norman Brinkley (plaid shirt), Earl Cauley, Leo Doyle, Everett Cauley, Hugh Dunnagan, Junior Dunnagan, Raymond Doyle, Floyd Carpenter, and Van Rusmisel. (Photo courtesy Jim Tennant.)

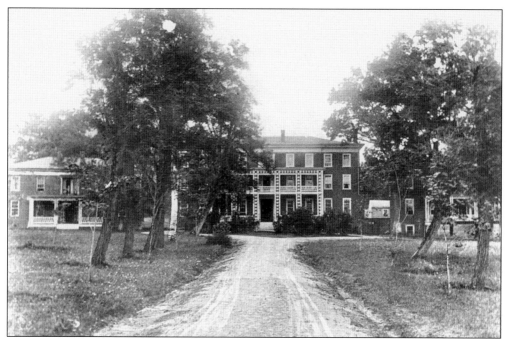

For decades, the Bath Alum Hotel provided hospitality to travelers on the Virginia Springs circuit. In the early days, railroad passengers would alight at the Millboro Depot, take a horse-drawn carriage to Bath Alum for a night's lodging, and then make the arduous, day-long mountain trek by carriage to the Warm Springs Hotel. Bath Alum was built in a flurry of tourism excitement in 1850; one writer described it as "fine enough to be mistaken for an insane asylum."

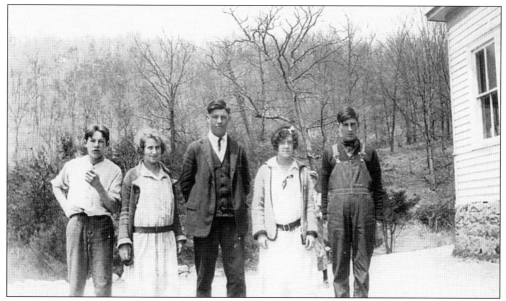

Teacher Emma Sue Hepler wrote on the back of this 1925 photo, "My fine students, all of whom I loved." The class at Williamsville School that year included from left to right Homer Burns, Josephine Stephenson, Howard Marshall, Carrie Hodge, and Leo Lockridge.

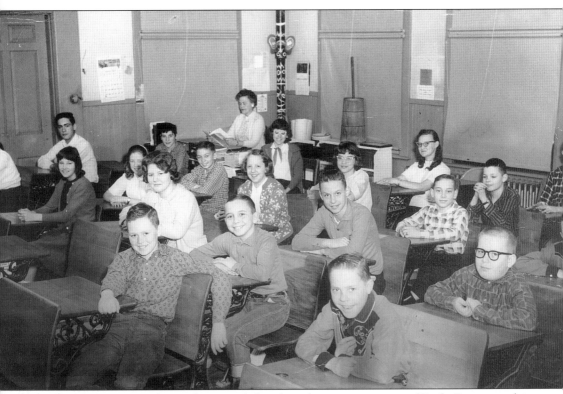

Mrs. Emma Sue Hepler Snider was a beloved teacher to generations of Bath County students. Her sixth grade class in 1962–1963 included, from left to right, (first row) Joseph Phillips, Gerald Bogan, and Johnny Phillips (Joseph and Johnny were identical twins and Mrs. Snider noted she "just had to separate to keep order"); (second row) Mike Shanks, Dwight Simmons, Eddie Jeffries, Jay Livick, David Lawrence, and Eddie Carter; (third row) Judy McCoy, Betty Kay Cauley, Rebecca Hepler, and Betty Layton; (fourth row) Sharon Shinault, Pamela Root, Donald Kennedy, and Patty Ann Geake; (fifth row) Sue Newcomb, Guy Ingram, Wayne Brinkley, and Mrs. Snider.

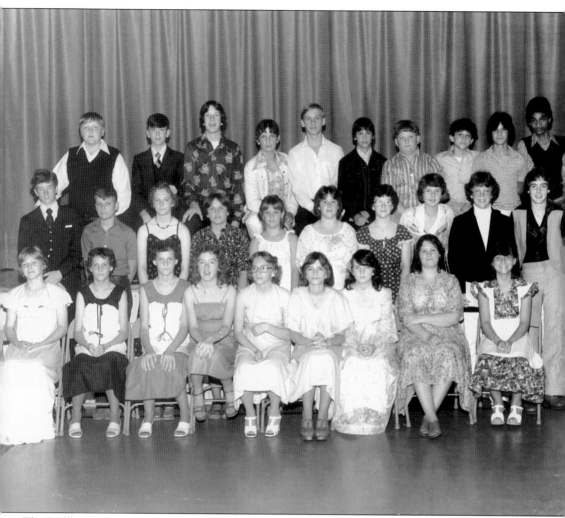

The Millboro Elementary seventh grade class of 1978 included, from left to right, (front row) Hallie Nicholson, Barbara Brinkley, Betty Brinkley, Sheila O'Neil, Vicky Riley, Bonnie Booth, unidentified, Gracie Hupman, and Patty Simmons; (middle row) Sean O'Neil, unidentified, Jeanie Shanks, Theresa Wells, Sandy McCoy, Cindy Clark, Julie Whitson, Fredericke von Arnswaldt, Roy Crummett, and unidentified; (back row) Bruce Puffenbarger, Gordon Kay, Eric Matheny, Peter Adams, Palmer Riley Jr., John Persinger, Wayne Hicklin, Fred Randozzo, David Seafross, and Robert "Wiz" Wright.

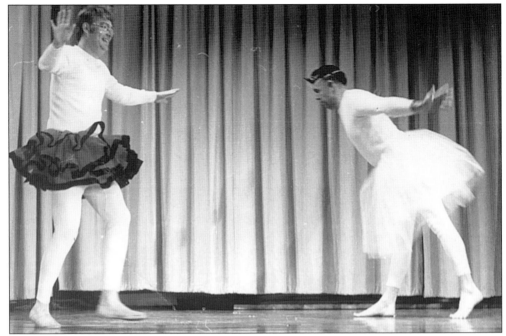

In the name of community service, Millboro Elementary School principal John Jenkins, left, and Millboro District Supervisor Harper Wagner, right, donned tutus and pirouetted across the stage in a school fund-raiser. This picture was found in a box of school photos from the late 1970s.

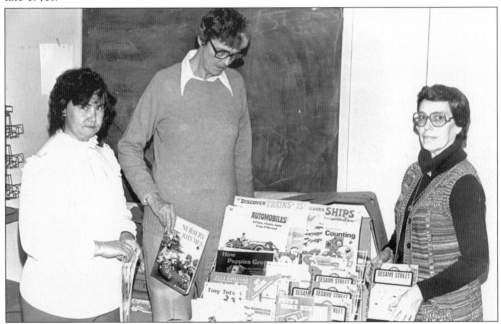

Participating in the "Reading is Fun-damental" program at Millboro Elementary in the 1970s were Constance Corley Metheny, Eliza Warwick Wise, and Lucille Plecker Rhea. Mrs. Rhea served on the Bath County School Board. Eliza Wise helped found the Bath County Historical Society; Mrs. Metheny worked at the society for 25 years.

Five

PLACES

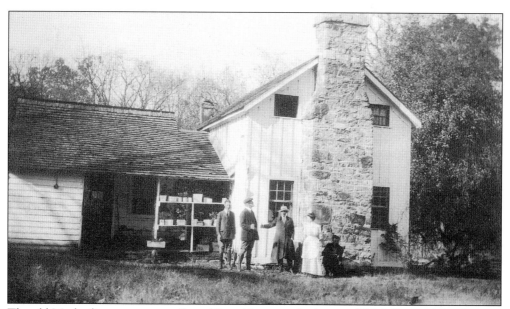

The old Methodist parsonage at Starr Chapel became the home of Ed Gillett and family.

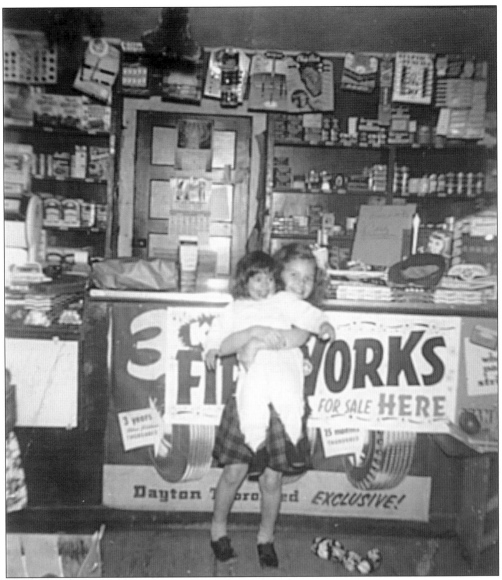

Here's a good look at what a country store offered for sale in 1953. The little darlings cavorting at the counter are Linda Tennant, age seven, and her baby cousin Betty Custer LaRue. Linda's father Jim owned and operated the store and gas station. (Photo courtesy Linda Tennant Weiss.)

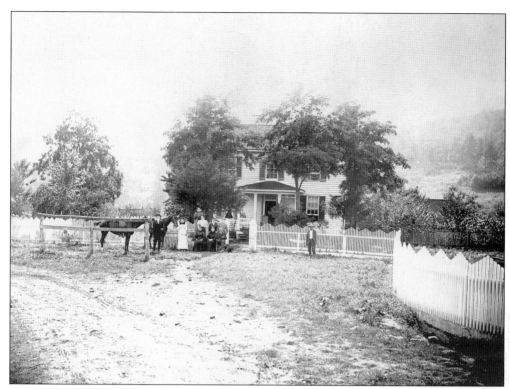

Austin Gwin's place, "Locust Grove," stood near the entrance to Richardson Gorge, along Cowardin's Run. At that time, this wide spot in the road was called Cowardin, Virginia. Mr. Gwin's sister, Maggie, had cloven hands and feet; she married a man named Moxley, lived in the village of Warm Springs, and is buried in the cemetery of Mount Hope church, overlooking this site.

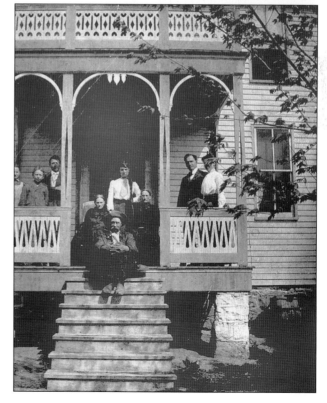

The Grose house, called "Thornhill," still stands at what is today called Queen Springs, along Cowardin Run near Bacova. At the time of this photo, the nearby village of Bacova Junction was known as Grose, Virginia.

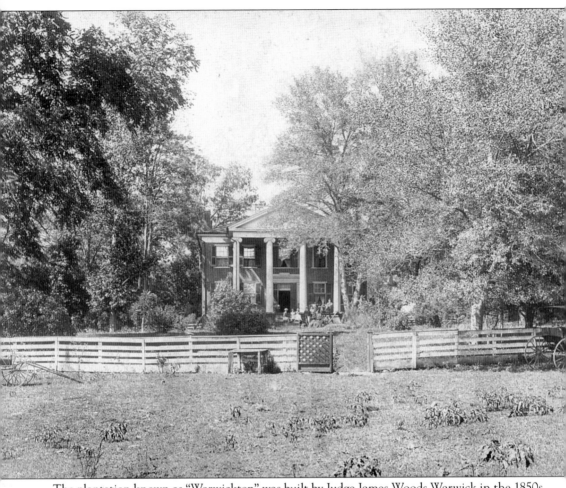

The plantation known as "Warwickton" was built by Judge James Woods Warwick in the 1850s. The house, pictured here in the late 1890s, has been meticulously restored by Ron and Pam Stidham. It was featured in the 1992 movie *Sommersby*, starring Richard Gere and Jodie Foster, and the Stidhams now operate it as Hidden Valley Bed & Breakfast. This photograph, from the collection of Marguerite McClintic Northern, depicts a Warwick family gathering. Mrs. Northern's mother, Ida Warwick McClintic, was one of the judge's daughters.

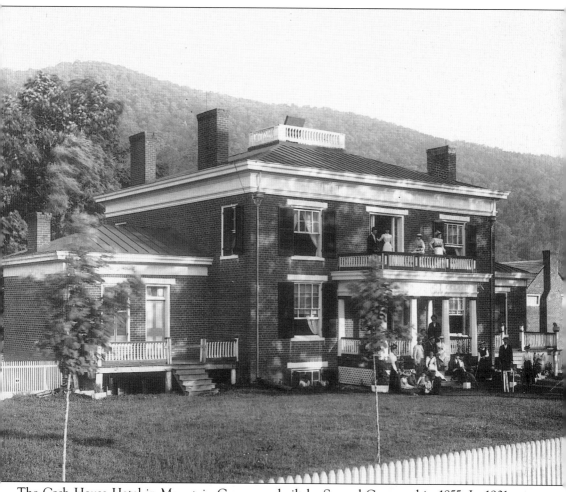

The Cash House Hotel in Mountain Grove was built by Samuel Gatewood in 1855. In 1901, when Henry Wise Hoover took this photo, the house sold to J.M. Cash, who operated it as a hotel. Croquet on the lawn was all the rage in that day. Cash sold the hotel in 1926; it again become a private residence and is occupied by Gatewood descendants.

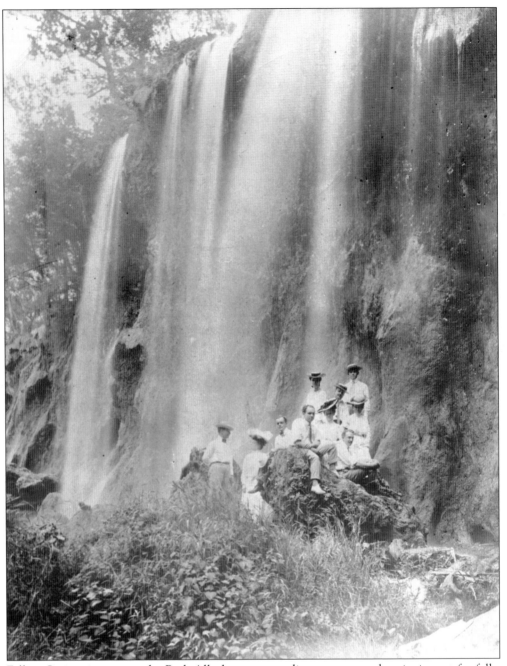

Falling Spring, just across the Bath-Alleghany county line, was a popular picnic spot for folks in the Gay Nineties, as this well-dressed party proves.

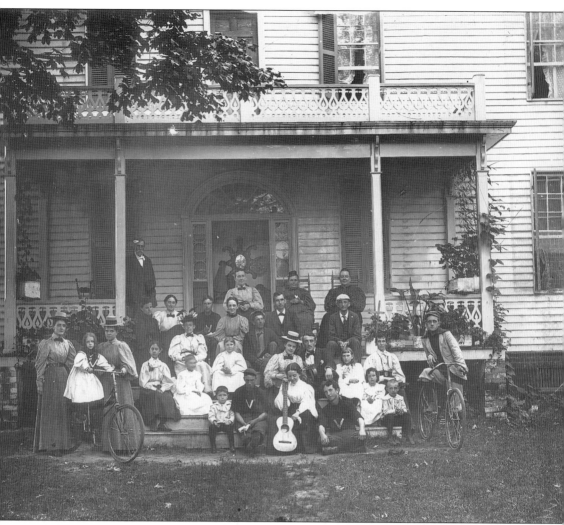

Henry Wise Hoover photographed a family reunion at Henry Massie's in the late 1890s. The house, south of the Bath-Alleghany county line, is still owned by the Massies.

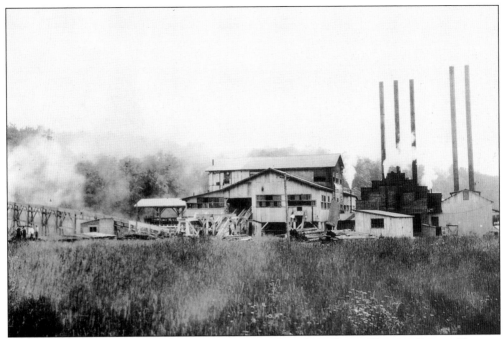

The Tide Water Hardwood Company operated a mill in the village of Bacova. Pictured here in full swing in 1925, the mill was serviced by two narrow-gauge railroads.

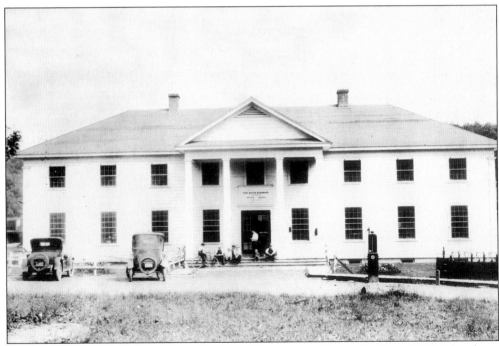

The Commissary of the Tide Water Hardwood Company still stands. Since 1965, it has been home to The Bacova Guild, which manufactured decorative items featuring the designs of artist Grace Gilmore.

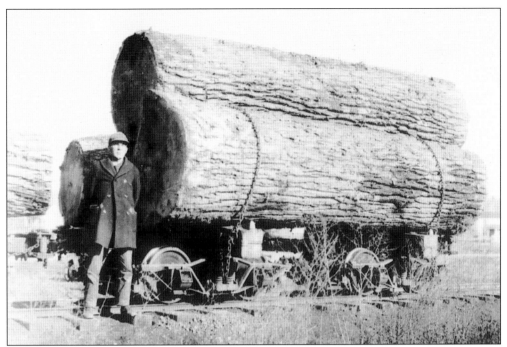

In 1925, virgin logs such as these were an everyday sight at Tide Water Hardwood in Bacova. About 100,000 board feet of lumber was sawed each day at what was then the largest lumberyard on the East Coast.

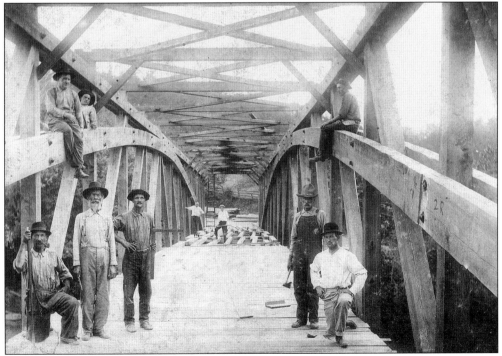

Workmen took a break from their labors in the late 1800s to be photographed building the bridge over the Cowpasture River at Scotchtown Draft in northeastern Bath.

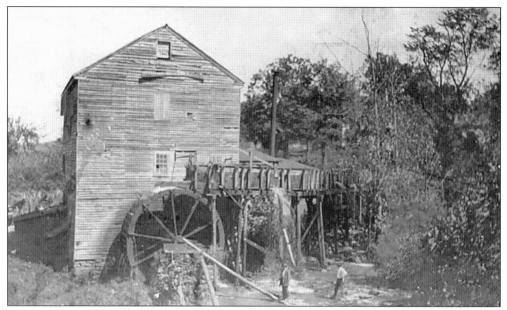

Cleek's Mill, along the Jackson River near Bolar, was once a bustling little burg with a busy mill, shown here, and even a post office. This mill was operated by George Washington Cleek (1835–1910).

The Wilson Oak still stands along Route 220 near Bolar. In 1763, this oak sheltered the Wilson family cabin. In July 1763, Shawnees attacked the family with tomahawks, wounding old Mrs. Wilson and her daughter Barbara. Susan Wilson was ironing clothes inside the cabin. When the Shawnees tried to pry open the door, she burned their fingers with the iron. A son Thomas was taken captive; he died of typhoid fever in 1765.

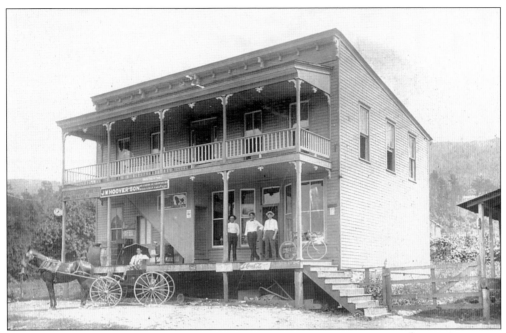

Hoover's Store in Mitchelltown has always been a commercial venture. In this early photo are Phil Rucker in wagon, Kenneth Hoover, Milton Terrill, and H.L. Woodzell Sr. The old store later served as the Mick-or-Mack grocery, a Sears-Roebuck catalog outlet, and the Bath office of *The Recorder* newspaper.

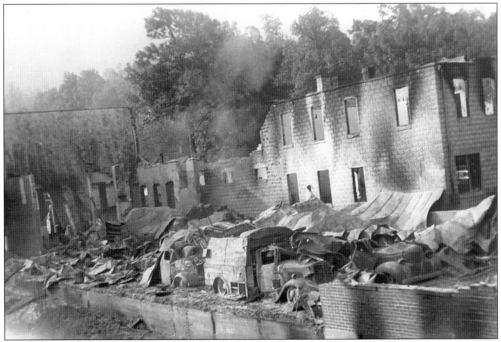

The late-night fire at Hepler's Garage in Mitchelltown about 1940 was the talk of the town. The blaze spread to the adjacent Fitzgerald's Store, which was also destroyed. These buildings stood where Home Oil Company is today.

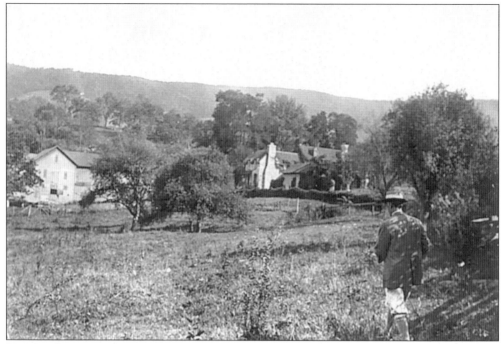

In 1922, Gramercy Farm at Dunn's Gap was hardly the showplace it is today. Artist Sergeant Kendall and his wife Christine (who took this photo) considered buying the estate, but the Dunn family held onto its legacy. The house was earlier a stagecoach stop, and then a girls' school known as "Rock Springs." Mr. Lanier Dunn bought the estate in 1880 and dubbed it "Gramercy," which means "God's mercy," after recovering from a grave illness. In 1925, the Dunns began extensive renovations to the exterior and interior of the house, and landscaped the grounds.

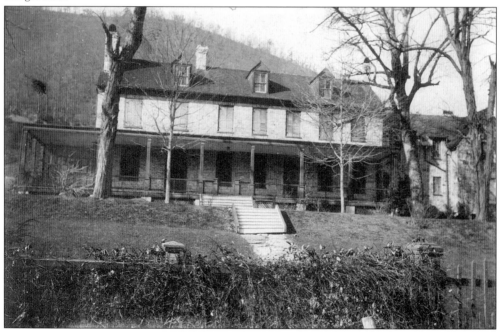

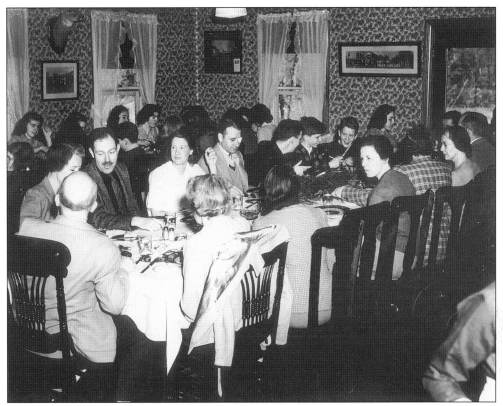

Diners were always fulfilled and happy at one of Miss Sally's fabled Fassifern Sunday dinners. The menu included fried chicken, country ham, spoon bread, and baked apples. Miss Sally was famous for the waffles she dished up for dessert.

Miss Sally Mines, mistress of Fassifern for many years, poses with her chauffeur, John Wilson, and "Little Bit," the beagle.

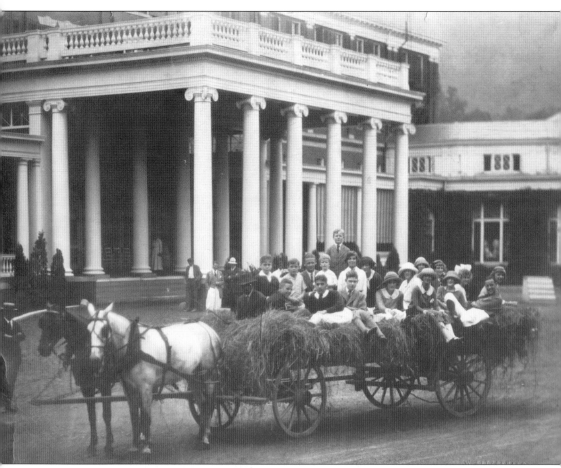

A horse-drawn hayride packed with happy revelers was a common sight around The Homestead in the 1920s.

Six

FACES

While neither this family group nor their white cat is identified, the house is quite distinctive, architecturally. The photograph was among Henry Wise Hoover's glass plate negatives.

Mandy Woodford, left, and Susan Kenney were photographed in Warm Springs by Joseph T. McAllister. Both women were former slaves; Susan favored smoking a corncob pipe.

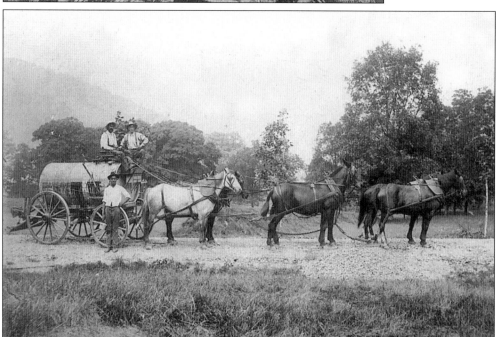

This wagon, loaded with oil or water and drawn by a team of six sturdy horses, was driven by Wade H. Patteson. Standing on the wagon is Julian Patteson and, still firmly planted on the ground is Godfrey Barrett.

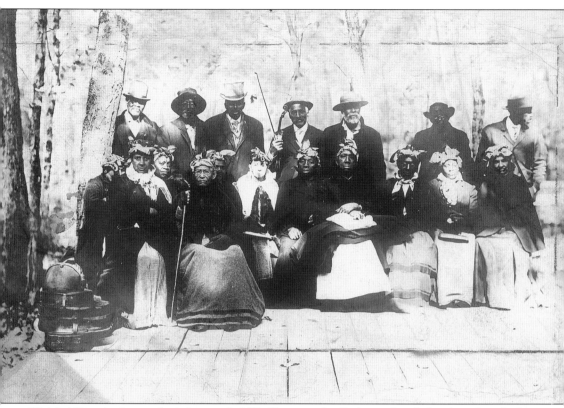

J.T. McAllister's photo, which he entitled "Ex-Slaves at the Barbecue," includes Ann Crawford Lindsay Morris, 1832–1917, second from left on front row. She was identified by a descendant, Perlista Y. Henry. Ann was born a slave on the Ervin plantation at Fort Dinwiddie; her mother and sisters were sold to another slave owner in South Carolina and never seen again.

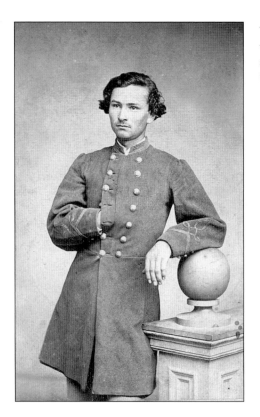

Young Confederate soldier William A. Byrd was born in 1844, the son of Nancy McClintic and A.H. Byrd. He became a physician after the war, and later died of sunstroke.

This photograph labeled "Aunt Mary McClintic" was among those in the McClintic-Arbuckle collection. That branch of the McClintic family lived on land that was flooded to create Lake Moomaw.

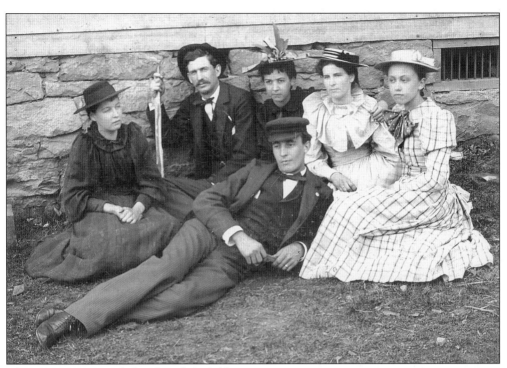

This serene sextet includes, from left, Addie Burdette, Mr. Price, Nora Nuhus, Blanche Burdette, and Ida Fry. The gentleman lounging in the foreground is not identified on the back of the photograph, one of many George W. Cleek bequeathed to the Historical Society.

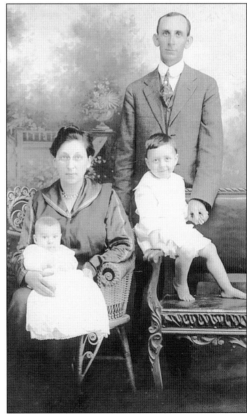

Historian George Washington Cleek, with his wife, Seraphine Ritenour Cleek, baby Thornton Ritenour Cleek, and toddler Given Wood Cleek.

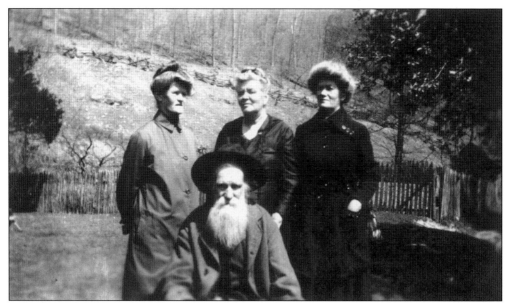

William Woodzell was a Confederate soldier and the patriarch of a large family. He is seated here in front of his daughter Lillie W. Campbell, his wife Lucy, and daughter Nettie W. Hodge.

Mrs. Emma Green Hodge.

Little Boyd McDannald, born August 12, 1879, to John P. and Sarah McClintic McDannald, grew up to be a physician. He died in Warm Springs in February 1934, a victim of carbon monoxide poisoning, from an oil stove in an unventilated bedroom.

Fanny Woodzell Roberts.

Sally Seibert married Robert M. Mustoe, who served as Bath County treasurer. Sally was a teacher; after retirement, she worked as a substitute into the late 1960s.

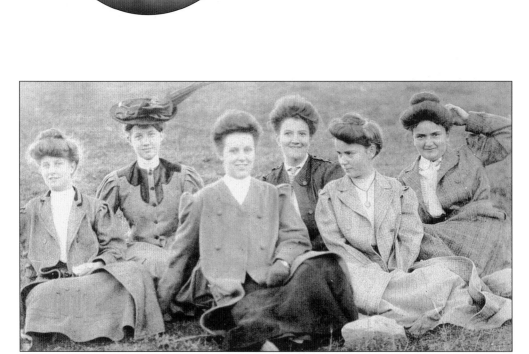

These six lovely ladies charmed Bath and Highland society around the turn of the 20th century. They are, from left to right, Jessie Campbell (Mrs. Harry Bird), Elsie Burns (Mrs. Charles B. Landreth), Elsie Slaven (Mrs. Jake Lunsford), Rachel Oglivie, Martha Bird, and Margaret Bird.

This photo from the George W. Cleek collection, entitled "The Stephenson Girls and Friends," carries this identification: "Emma Pritt, daughter of James and May Pritt, later married Frank Pritt; Hattie Stephenson; Susie Stephenson; Edmonia Stephenson later married Charles Armstrong; Hettie Stephenson later married Fred Gwin; Nannie Bratton; Eliza Stephenson, died June 20, 1929."

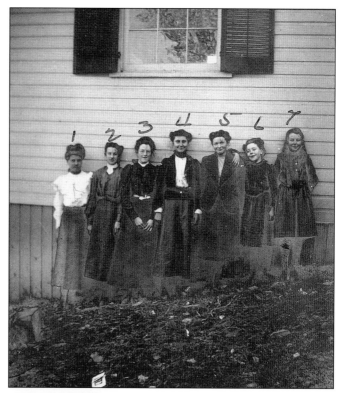

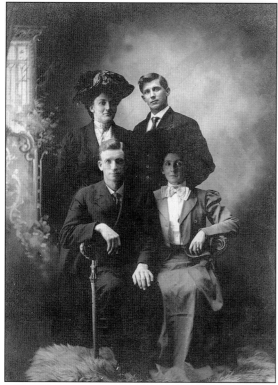

This well-dressed foursome features Ed McClintic and Mary Warwick, front, and Eva Woodell and Kent Echard.

The identity of the "Toothsome Threesome" is unknown. Apparently, they were friends of Henry Wise Hoover and served as "models" for the well-known, prolific photographer in the 1890s. For some peculiar reason, the trio traipsed about posing at various sites, always using as props a Zuleika tobacco advertising sign, a flyer touting a church dedication on September 25, and a book with an unknown title. These photos were probably taken on the same day in 1893.

Reba and Buster Maxwell lived the good life in Bacova in 1925.

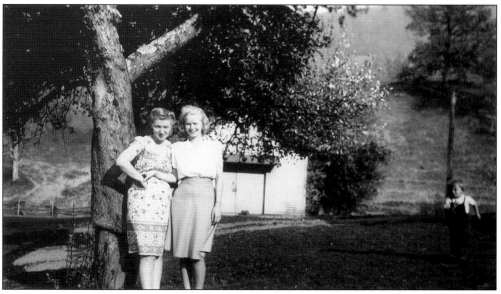

Roena and Lorena Helms were belles of Bolar.

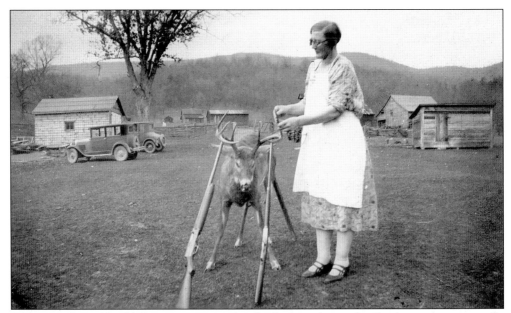

Bess Gum (Mrs. Frank) Bratton poses with a buck that, despite his lively stance, is actually quite dead.

John F. Bratton was born in 1827. He and his wife Cornelia had 10 children and raised them on the farm that is today home to John's grandson Leonard F. Bratton and his wife, Elizabeth. They are known to all as "Buck" and "Sallie."

Joseph Hamilton "Ham" Burns was a teacher who lived in Little Valley, near Bolar. He is pictured here with his youngest son, Basil, who was crippled and afflicted with a hunchback.

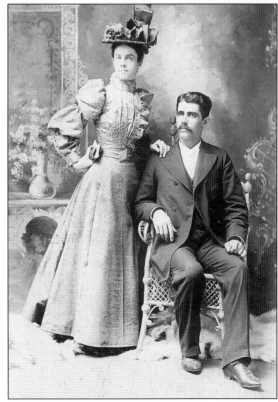

This photograph of Rev. and Mrs. R.N. Hartness is from the George W. Cleek collection. Reverend Hartness was probably the pastor at Stony Run Church near Bolar.

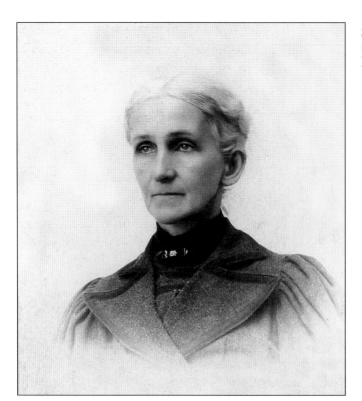

Sarah Ann "Annie" Cleek married Charles Francisco Revercomb in 1866.

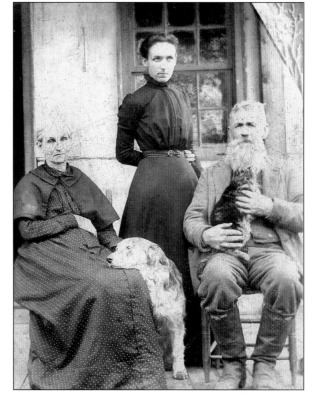

Also in 1866, Henry Harrison "Tip" Revercomb, brother of Charles F., married Harriet Cleek, sister of Annie. Pictured here on their porch near Bolar are Harriet Cleek Revercomb, Tip, and their daughter, Mary Emma Revercomb McCormick.

Cordelia Cleek Williams' twins, Hubert and Herbert, were born in 1904.

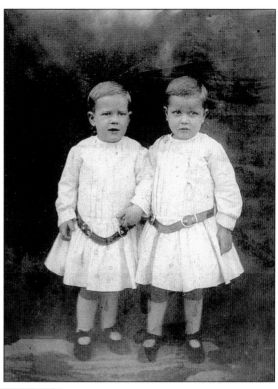

Sallie Byrd Cleek, born in 1875, married Lothian Roy Bowers in 1906. She died in 1909.

Baby Frank Eakle was born on May 12, 1901.

William Holmes McGuffin was born July 30, 1903. Holmes and his wife Reefa Belle, a teacher, lived in a Victorian farmhouse on Route 220 near Bolar.

Artist and musician Christine Herter Kendall, wife and former student of artist Sergeant Kendall, paints on her estate known as "Garth Newel." For 30 years, The Garth Newel Music Center, bequeathed by Mrs. Kendall, has provided a beautiful, pastoral site for chamber music concerts in Herter Hall.

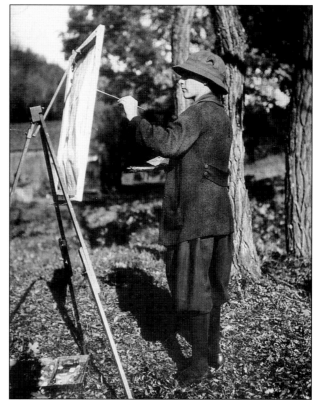

George B. Revercomb was photographed on his porch with daughters Bettie, left, and Ella.

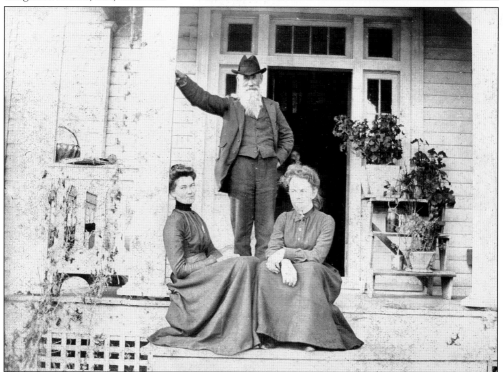

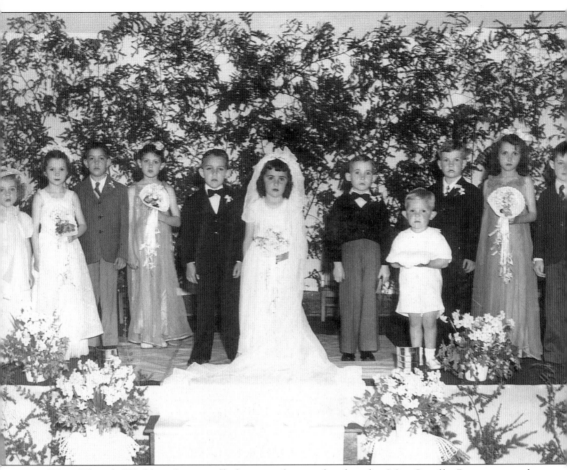

"Tom Thumb Weddings" were all the rage during the decades Miss Lucille Bonner ran the elementary school. This 1948 production took place at Warm Springs. From left to right are flower girl Shirley Hoover, maid of honor Nancy Byrd, usher Freddie Ryder, unidentified bridesmaid, groom Donald Bogan, bride Pat Stinnett, preacher Johnny Criser, best man Floyd Kay, ring bearer Grey Lee Hicks, bridesmaid Edna Law, and usher Burton Trimble.

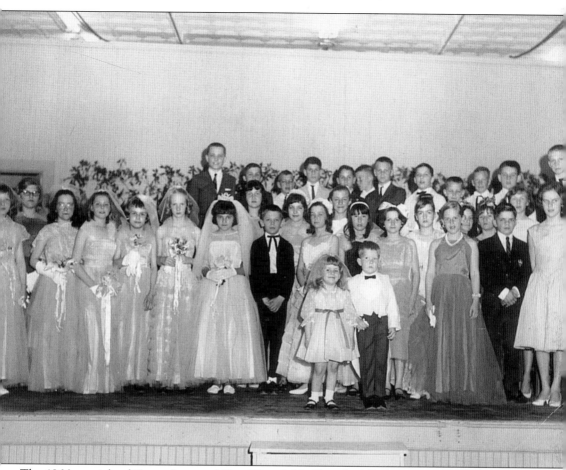

The 1966 nuptials of "Jenny June and Tom Thumb," held at the Mitchelltown school, features minister Steven Hinton, bride Betty Winebriner, groom Ray Cox, and Susan Perkins as maid of honor. Bridesmaids were Wilma Pate, Della Page, Becky Failes and Angie Mines. Cindy Stinnett was the flower girl, and William Guerrero was the ring bearer. The best man was Michael Lindsay. Greg Martin was father of the bride, and Karen May was Mrs. June; Connie Rodgers and David Black portrayed the groom's father and mother. Sandra Woodzell and Vicky Peery dressed as grandmothers. Guests included Terry Gram, Mike Solomon, Terry Leslie, Phoebe Ryder, Ricky Fry, Karen Cutlip, Brenda Duncan, Richard Mines, Gladys Martin, Dreama Woodzell, and Patricia Shifflett. Ushers were Mike Burns, David Lindsay, Lennie McElwee, and L. Smith.

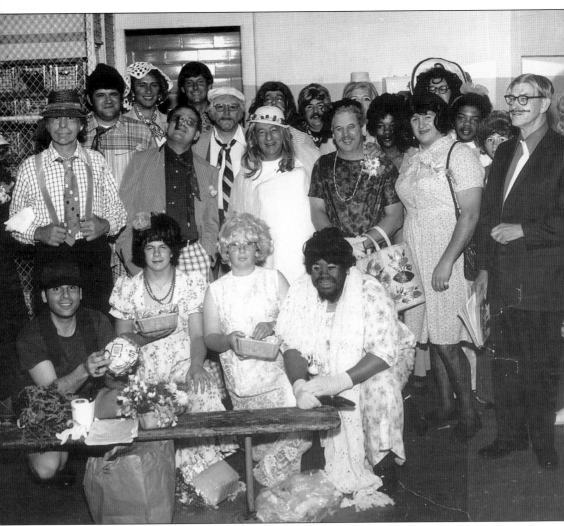

Dressing up for a worthy cause—a "Womanless Wedding" in May 1978—were, from left to right (front row) Ed Foreman, David Lindsay, Dennis Carter, and Irwin "Pappy" Black; (middle row) Ray Rodgers (Grandma), Jim Lindsay (Grandpa), Percy "Buzz" Nowlin III (groom), Delegate E.S. "Shad" Solomon (bride), Urban "Jake" Cleek (maid of honor), Jimmy Kellison (Nosy Neighbor), and Rev. Warren Rollins (minister); (back row) Mike Basham, Frankie Pritt, Eugene Carpenter, Edsel "Tommy" Ford, Jim McGinnis, David Kershner, Duncan M. Byrd Jr. (soloist), Houston Pettus, Hugh Gwin (narrator), Ernie Wright, and an unidentified lovely. Randy Stephenson, portraying the "Jilted Sweetheart," was weeping in the corner when this photo was taken.

Dr. Ira T. Hornbarger was born in Healing Springs in 1896. He practiced in Bath County from 1922 until his death in 1973. Fay Ingalls called Dr. Hornbarger "my favorite shooting companion." Dr. Hornbarger's contributions to the community include chairmanship of the Bath County School Board, director of the Bath County National Bank, and the presidency of the Bath County Historical Society. His daughter, Mary H. (Mrs. Harvey) Mustoe carries on this tradition of community service.

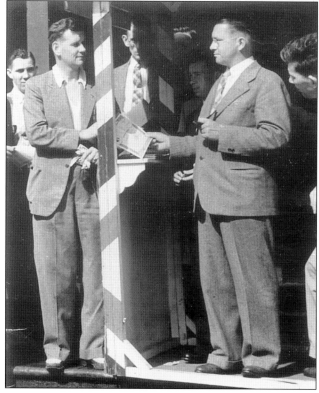

Julian "Butter" Byrd, left, bought the first war bond from Eddie Bonner, right, in the early 1940s. In an interesting twist, Byrd's son Keene married Bonner's daughter Betsy in 1993. (Photo courtesy Betsy Bonner Byrd)

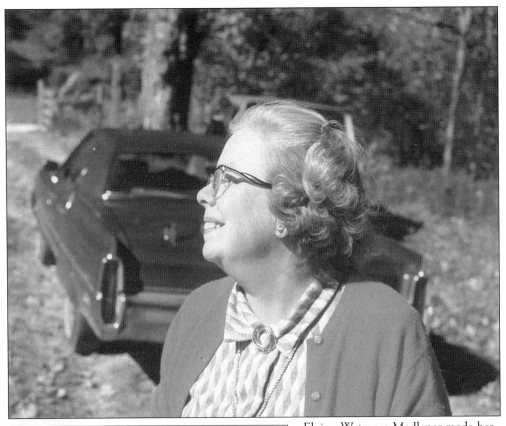

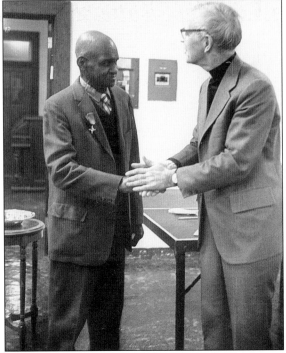

Elaine Wetmore Madlener made her vision of a Bath County Historical Society into reality in 1969, with assistance from Edna Johnson Helmintoller and Eliza Warwick Wise. As a young debutante, Miss Wetmore spent summers as an Arthur Murray dance instructor. This brought her to The Homestead, where she met her beau and later husband, Otto Madlener.

Paul Linthicum, left, was honored by Rev. George Wickersham and the congregation of St. Luke's Episcopal Church in Hot Springs for 40 years of janitorial service.

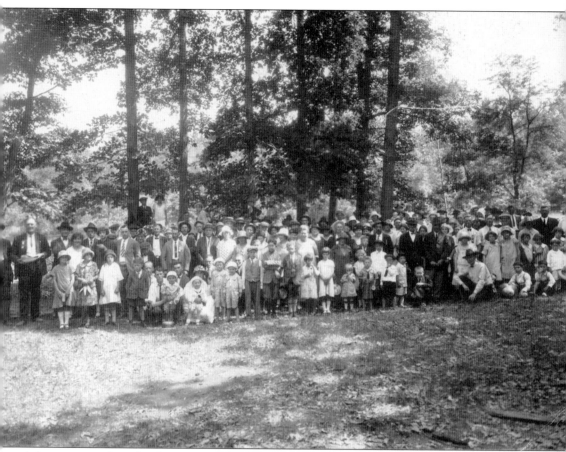

A huge group of revelers known as "The Woodmen" gathered at Bath Alum for a picnic in August 1926.

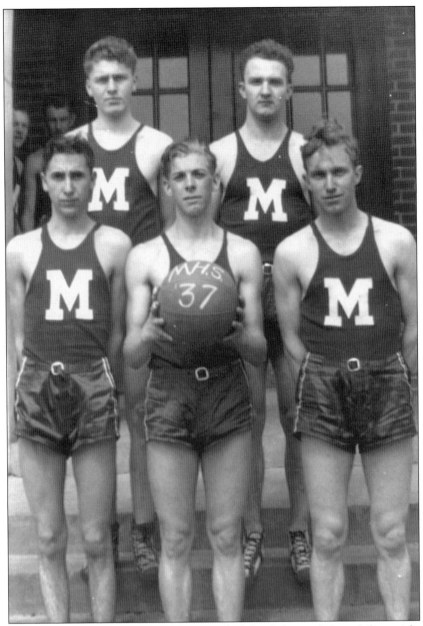

The 1937 boys' basketball team at Millboro High School featured from left to right (front) Ralph Bethel, Jeff Cauley, and Graham Hicklin; (back row) Edwin Sutton and Lowell Curry.

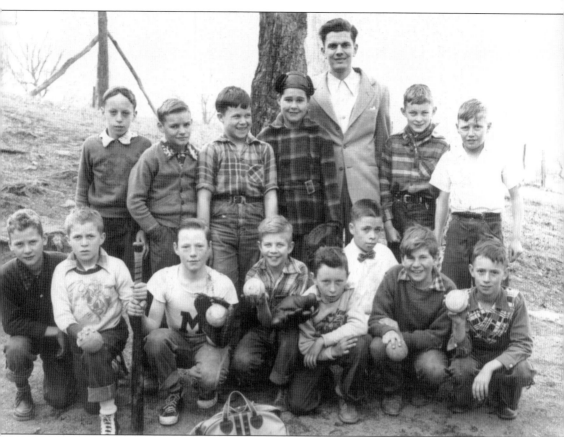

Principal Lucille Bonner (Gleim) identified this photo in her scrapbook as "Johnny's Boys." From left to right are (front row) ? Cauley, Jimmy Brinkley, Tommy Ford, Eddie Green, Toby Stanley, Buddy Giles, Jimmy Green, and Jay Loan; (back row) ? Stanley, James Cauley, Richard Thacker, Edgar Hawks, coach and teacher Johnny Gazzola, Tommy or Charles Snyder, and Jackie Terry. The photo was taken at the old Mitchelltown School in the 1940s.

OFFICERS

President: Peter Pitard
Vice-president: Sarah Hagen McWilliams
Secretary: Jay Batley
Treasurer: Jean Howell

BOARD MEMBERS

Richard Armstrong
Betsy Byrd
Nell Carpenter
Beth Eley
Janice McWilliams
John C. Singleton
Michael Wildasin

Bath County Historical Society
Courthouse Hill, P.O. Box 212
Warm Springs VA 24484-0212

(540) 839-2543
email: bathcountyhistory@tds.net
website: www.bathcountyhistory.org